Cats
in Bow Ties

Photographs &
Rescue Stories
of Shelter Cats
with Style

Lindsi Jones

AMHERST MEDIA, INC. ▸◂ BUFFALO, NY

Dedication

To every cat I have ever loved—especially Sam, Zero, Cleo, and Zookie. Thank you for loving me, and for being my companions and source for inspiration and unconditional love.

Published by:
Amherst Media, Inc.
PO BOX 538
Buffalo, NY 14213
www.AmherstMedia.com

Publisher: Craig Alesse
Associate Publisher: Katie Kiss
Senior Editor/Production Manager: Michelle Perkins
Editors: Barbara A. Lynch-Johnt, Beth Alesse
Acquisitions Editor: Harvey Goldstein
Editorial Assistance from: Carey A. Miller, Roy Bakos, Jen Sexton-Riley, Rebecca Rudell
Business Manager: Sarah Loder
Marketing Associate: Tonya Flickinger

ISBN-13: 978-1-68203-422-4
Library of Congress Control Number:2019932352

Printed in the United States of America
10 9 8 7 6 5 4 3 2 1

AUTHOR A BOOK WITH AMHERST MEDIA

Are you an accomplished photographer with devoted fans? Consider authoring a book with us and share your quality images and wisdom with your fans. It's a great way to build your business and brand through a high-quality, full-color printed book sold worldwide. Our experienced team makes it easy and rewarding for each book sold—no cost to you. E-mail **submissions@amherstmedia.com** *today.*

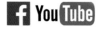 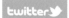 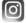

www.facebook.com/AmherstMediaInc
www.youtube.com/AmherstMedia
www.twitter.com/AmherstMedia
www.instagram.com/amherstmediaphotobooks

Contents

About the Author

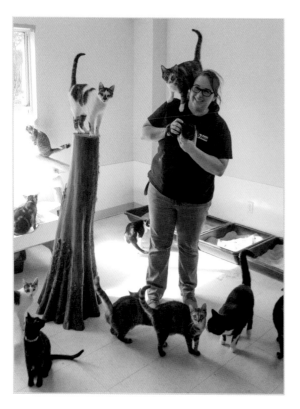

After graduating from Valdosta State University with a bachelor's degree in fine art education, Lindsi began working as a wedding and portrait photographer and traveled North America, building an award-winning photography business. Hundreds of weddings and thousands of portraits later, she wanted to find a way to give back to the world and local community by forming a partnership with local feline rescue group, Miss Kitty Feline Sanctuary in Thomasville, Georgia. Each time Lindsi photographs a wedding, she donates to the shelter on behalf of the happy couple. In addition to monetary donations, Lindsi spends volunteer time getting to know the cats in the shelter and taking photographs, which help with adoptions. In 2015, she began a unique portrait project titled 101 Cats in Bow Ties, which resulted in an installation-style art exhibition featuring portraits of high-fashion felines dressed up in bow ties, which she handmade exclusively for the project.

Lindsi Jones is an American photographer born and raised in southern Georgia. Since childhood, Lindsi has held a deep admiration and affection for cats. Always inspired by feline friends, she extensively photographed her pet cats and developed aspirations to become a professional artist.

Lindsi has continued the Cats in Bow Ties project and now works with many shelters to highlight adoptable felines and create exceptional portraits used in social media and other advertisements that aide adoption efforts and celebrate cats worldwide. Her work with shelter animals has been featured on television and in numerous online publications, newspapers, magazines, and advertisements.

Introduction

During my life, I have met and fallen in love with many cats. Companions, allies, friends—these furry creatures have always made a mark upon my heart in ways that no other living beings ever have. They never fail to bring me comfort or make me smile. After a lifetime of loving cats and spending time volunteering as a shelter photographer, I wanted not only to create an exceptional series of photographs celebrating and highlighting the exquisite beauty and physical attributes of rescue cats, but also to prove that just like humans, no two cats are alike, and each has a life history and story.

No papers or pedigrees, a rescue cat is typically found living as a stray, is abandoned at an animal shelter, or simply wanders into the life of their rescuer with an origin as mysterious as the universe. Often with rough starts in the world, periods of neglect, or having only known feral street life, these expectational animals overcome the trials of life through compassion and relentless love.

Pulling from my life and experience as a portrait photographer, I set up a mobile tabletop studio, shooting with a professional camera and a basic professional lighting setup. I selected a clean, gray background—the type often used in photography of supermodels or for catalog work. I used one fashion accessory, a bow tie, to bring stylish simplicity and unity to this collection of portraits.

Since its introduction, the bow tie has been an essential component in the wardrobe of many fashion-forward individuals. For centuries, this bold accessory has been worn by professionals, from doctors, to politicians, to entertainers and waiters. No matter one's place in life, aristocrat to plebeian, the bow tie represents sophistication, confidence, intellectualism, and a desire to stand out. From formal to casual, the bow tie has stood the test of time as an essential accessory worn by those wishing to be distinct and remembered—certainly a cat's top choice of outfit for their moment in the light.

The bow ties seen in this series were handcrafted and tailored specifically to complement the feline physique, in a variety of patterns and colors that complement each cat's features. These dapper pops of color bring whimsical rhythm and visual harmony to the series, resulting in a stunning collection of feline portraits.

All of the cats featured in the Cats in Bow Ties series are current and former residents or felines rescued by volunteers from Miss Kitty Feline Sanctuary. Their stories are true and based on experience from hours of care, adoption records, my time working with and photographing each cat, as well as information shared by their rescuers and adopters. Miss Kitty Feline Sanctuary is an official 501(c) 3 cat rescue organization located in Thomasville, Georgia, dedicated to the rescue and rehabilitation of abandoned and homeless cats in their community. They run a safe and secure no-kill facility with adoption services, while also supporting spay-and-neuter efforts throughout southern Georgia for both domestic and feral cats. Most of the cats featured in this book have been fortunate enough to find loving families and forever homes, though some are still awaiting adoption. Here are their stories. May they inspire you to smile, love, and support your local animal rescue groups.

To learn more about the Cats in Bow Ties project and Miss Kitty Feline Sanctuary, visit:

- www.catsinbowties.com
- www.misskittyfelinesanctuary.com

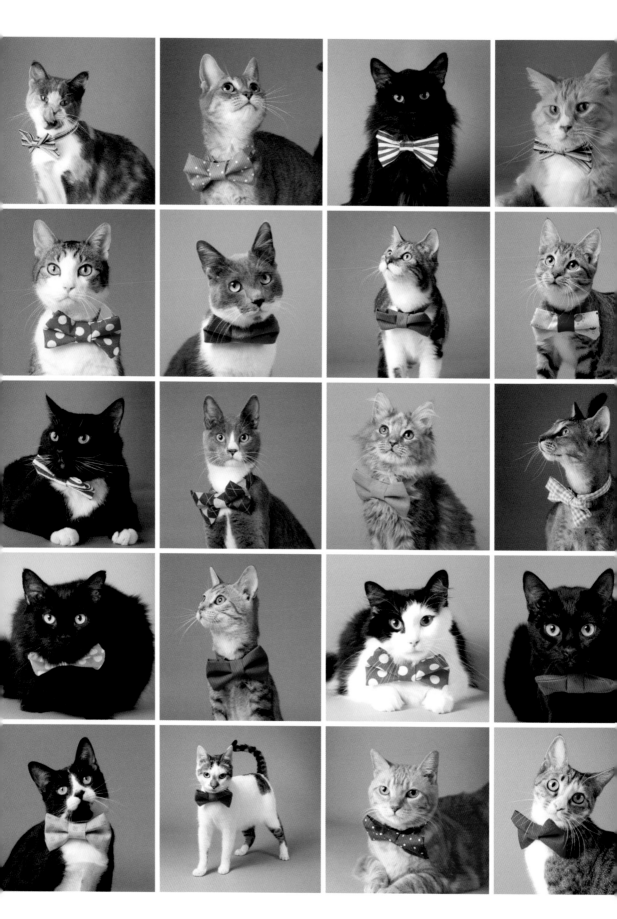

❀ Life at the Shelter

All 9 Lives

The cats pictured in this section have spent or will spend their entire lives in the care of Miss Kitty Feline Sanctuary. Whether it be due to a health issue, loss of a caregiver, or simply that the cat never finds anyone to adopt him or her, some cats spend all nine lives in shelter care. These cats are guaranteed a lifetime of sanctuary in the shelter. They are provided with essential veterinary care, food, and importantly, love. They enjoy a wonderful quality of life surrounded by other cats and loving volunteers.

"The cats pictured in this section have spent or will spend their entire lives in the care of Miss Kitty Feline Sanctuary."

Pumpkin

Named for her big, round, and orange appearance, Pumpkin lived her entire life in the care of Miss Kitty. Featured in newspaper articles, magazines, and numerous online features, Pumpkin was a bit of a local celebrity whose birthday was celebrated by shelter staff each year.

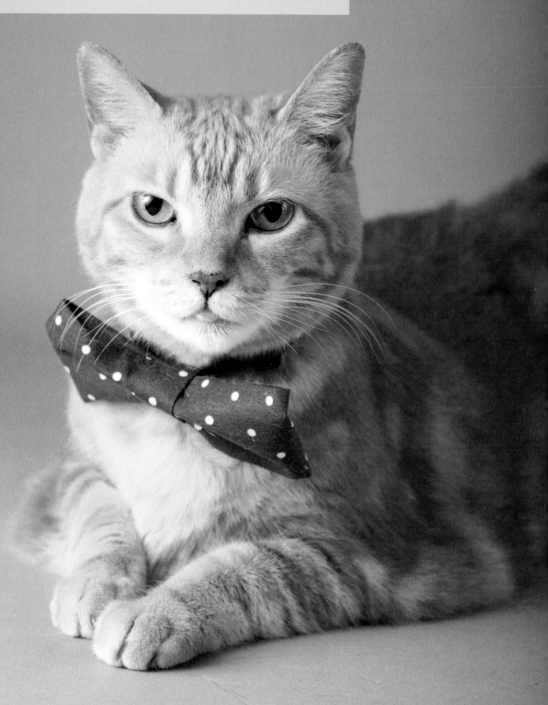

Miss Grinch

Miss Grinch is a petite gray tabby with a salty and sweet personality. One second, she would purr and rub against your leg, and the next she would nip at your fingers and hiss. She entered shelter care as a kitten and spent her entire life at Miss Kitty.

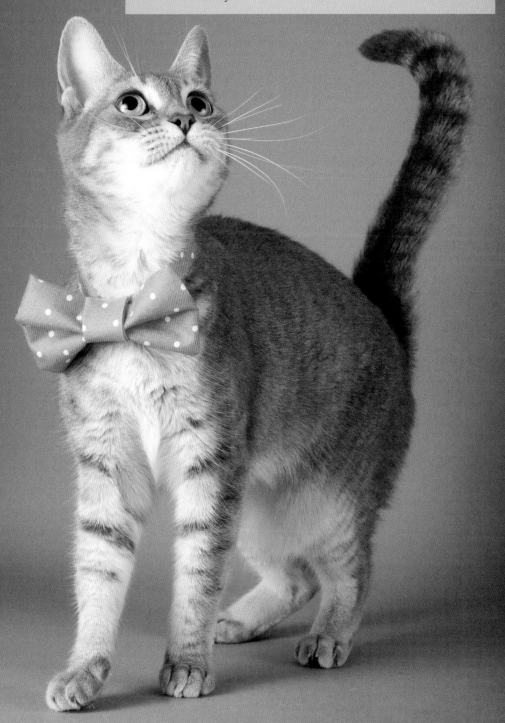

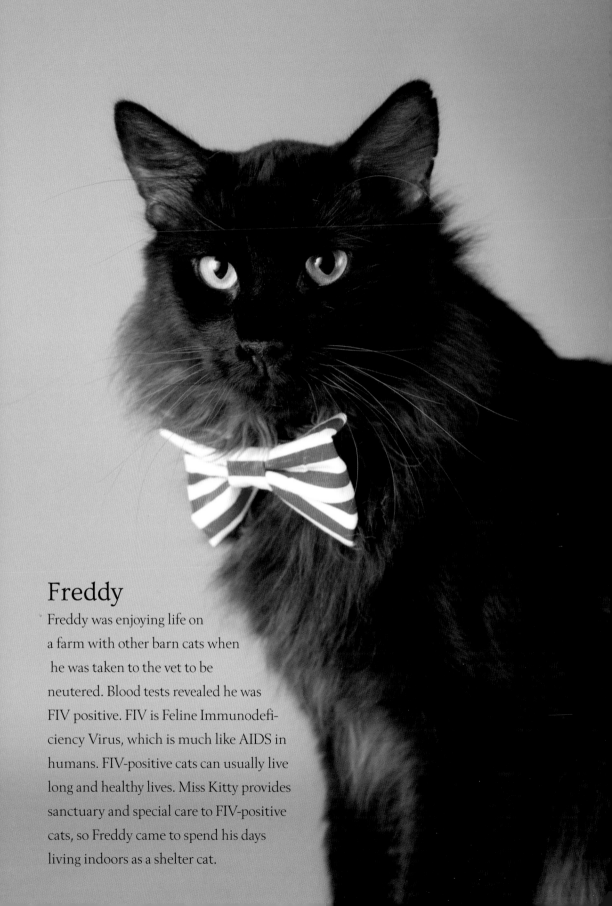

Freddy

Freddy was enjoying life on
a farm with other barn cats when
he was taken to the vet to be
neutered. Blood tests revealed he was
FIV positive. FIV is Feline Immunodefi-
ciency Virus, which is much like AIDS in
humans. FIV-positive cats can usually live
long and healthy lives. Miss Kitty provides
sanctuary and special care to FIV-positive
cats, so Freddy came to spend his days
living indoors as a shelter cat.

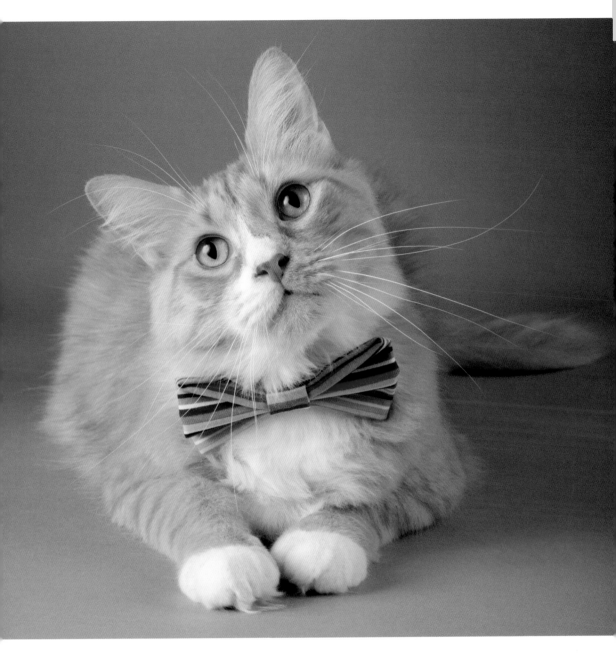

Mojo

Mojo, a giant ball of orange fluff, had a bad case of ear mites as a kitten, which resulted in his permanent but endearing head tilt. FIV-positive, he is a permanent resident of Miss Kitty, and his birthday is celebrated yearly. Mojo is a bit of a celebrity. His loud meow can be heard throughout the shelter, and he loves riding around the halls in the laundry cart.

Yolanda

(below) Found as a stray kitten, Yolanda made the most of her shelter time, prancing and playing with all the other happy kitties awaiting their forever homes.

Tuffy

(following page) Handsome Tuffy came to live in shelter care when his owner was moved into a nursing home. He lived out his life at Miss Kitty.

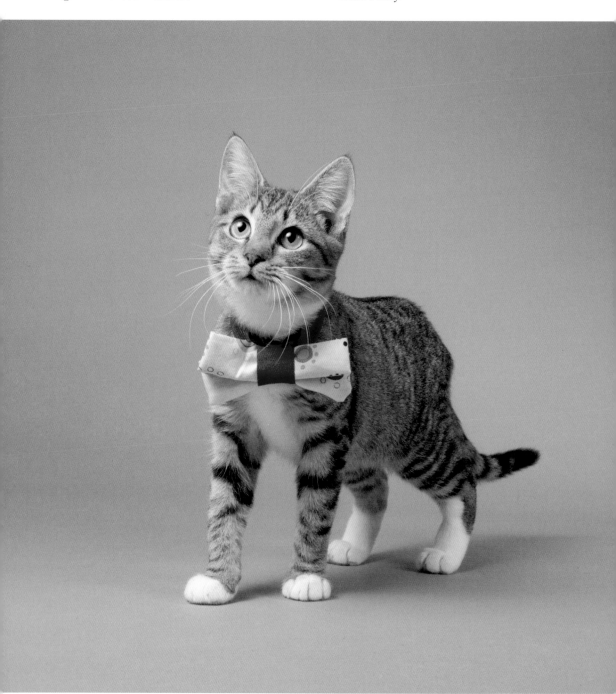

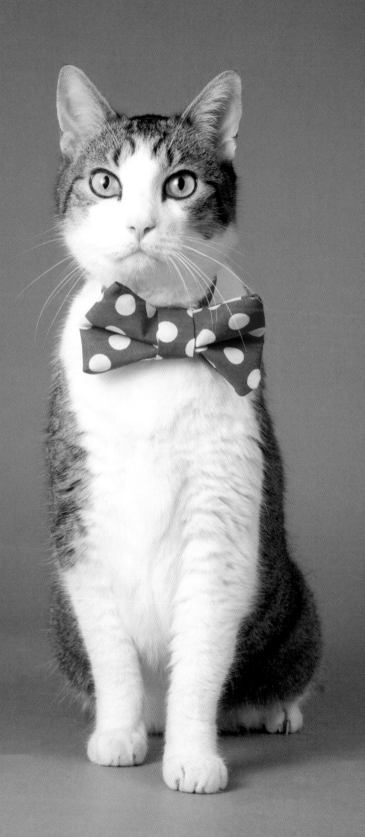

Pesto

The facial expression really describes what Pesto thinks about having his photo taken. I laugh every time I look at this portrait.

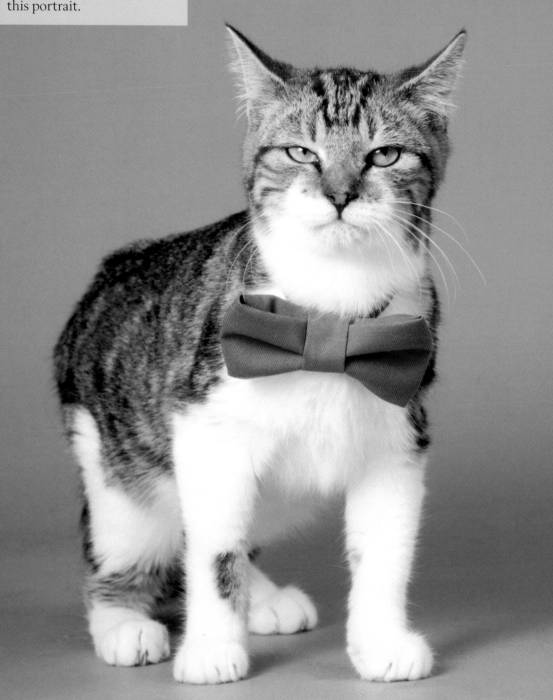

Monica

Frisky and sweet, this cute, silver-gray tabby spent her entire life in shelter care.

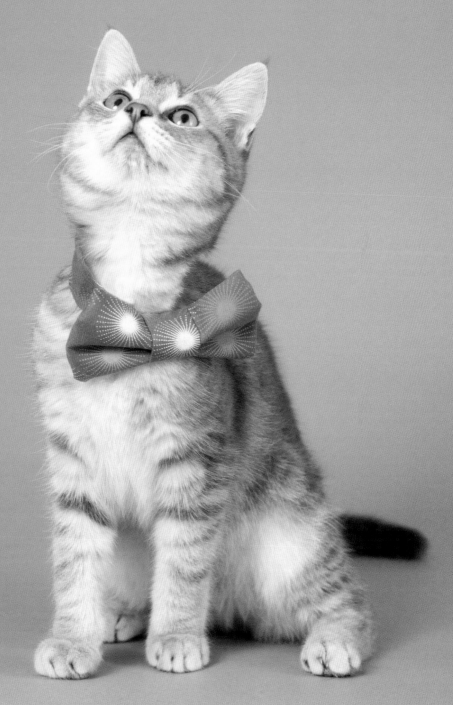

Oprah

Abandoned at the shelter, this smooth and sleek mini panther made her forever home with the other felines at Miss Kitty.

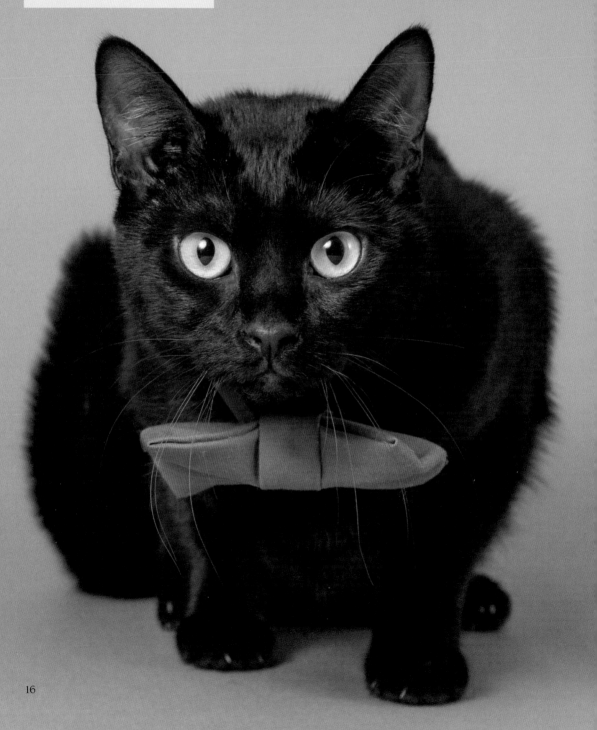

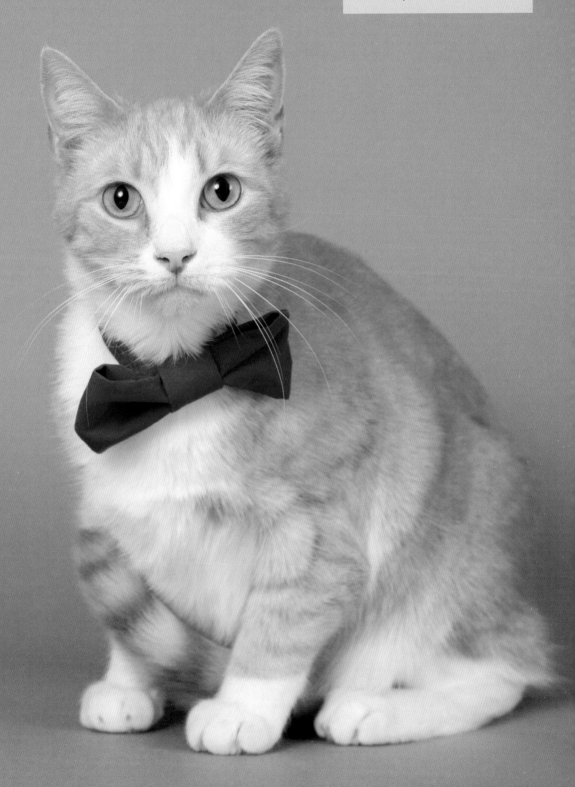

Micah

Micah was found as a stray and was always very shy. He lived six years in shelter care.

Rowdy

(below) Beloved and faithful, Rowdy lived with a founding member of Miss Kitty. After his owner was diagnosed with a terminal illness, Rowdy brought him comfort and companionship by demanding to sit at the foot of the bed. He came to live his remaining days at the sanctuary after his owner passed away.

Erin

(following page) This sweet little fluff ball was very playful and frisky during our photo shoot. She looked as if she were waving hello in every frame. Erin lived her entire life in shelter care.

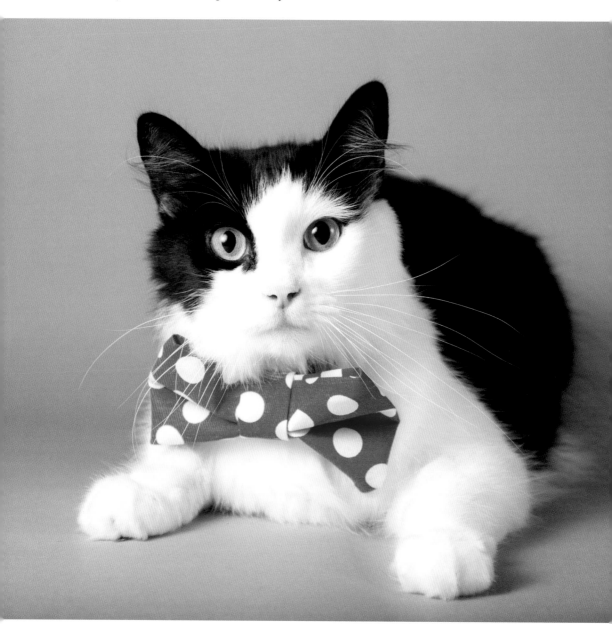

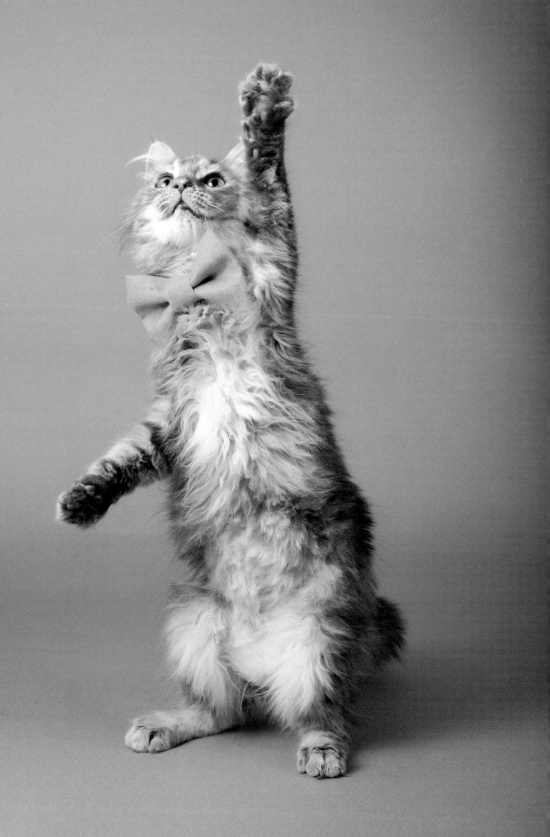

☻ Up for Adoption

Current Shelter Residents

The fine felines featured in this section are currently spending their time looking out the window and wondering if there is more to life. Ready to sleep in a real bed, receive daily cuddles, and be faithful companions, these kitties are looking for final, permanent rescue.

"Ready to sleep in a real bed, receive daily cuddles, and be faithful companions, these kitties are looking for final, permanent rescue."

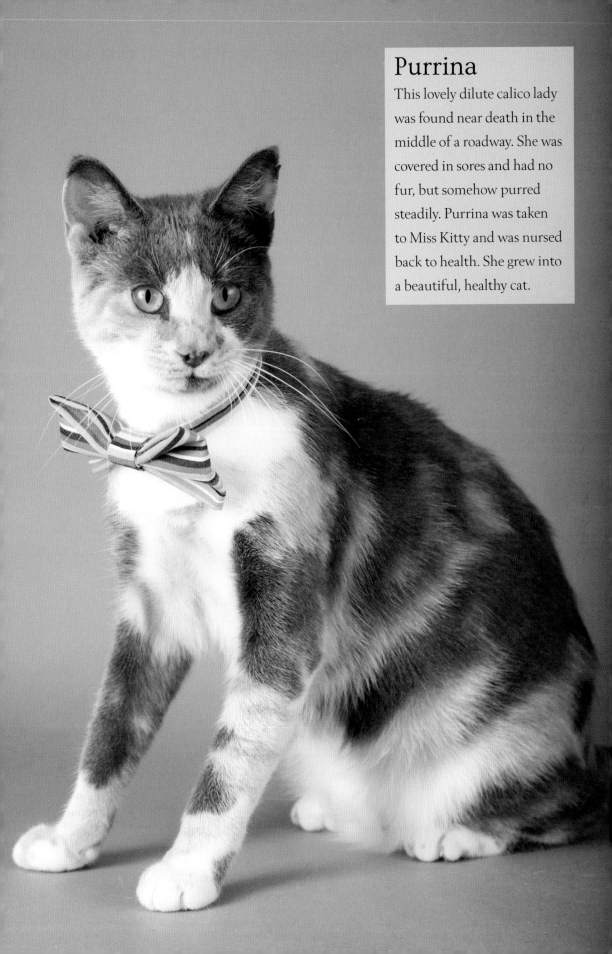

Purrina

This lovely dilute calico lady was found near death in the middle of a roadway. She was covered in sores and had no fur, but somehow purred steadily. Purrina was taken to Miss Kitty and was nursed back to health. She grew into a beautiful, healthy cat.

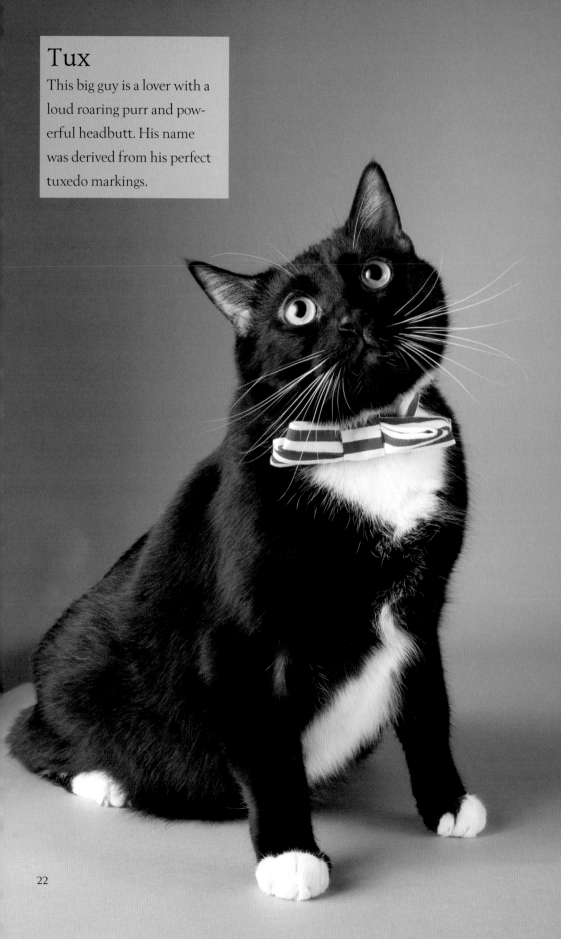

Tux

This big guy is a lover with a loud roaring purr and powerful headbutt. His name was derived from his perfect tuxedo markings.

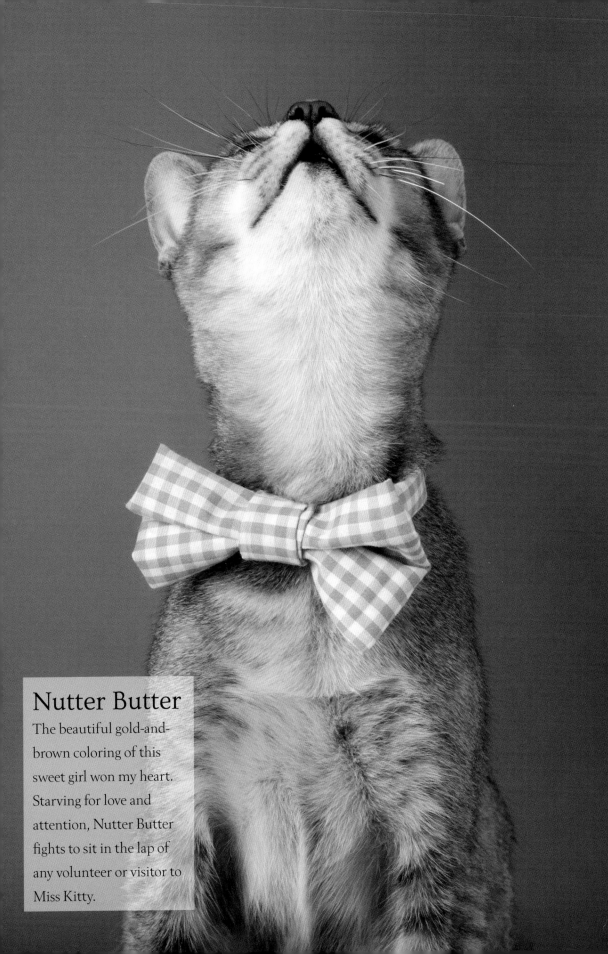

Nutter Butter

The beautiful gold-and-brown coloring of this sweet girl won my heart. Starving for love and attention, Nutter Butter fights to sit in the lap of any volunteer or visitor to Miss Kitty.

Pansy

A shy but sweet cat, Pansy has spent most of her life in a shelter. Over the years, she has lost all of her teeth and now enjoys a diet of soft, canned food. Pansy is currently interviewing applicants for the position of permanent caretaker and personal chef.

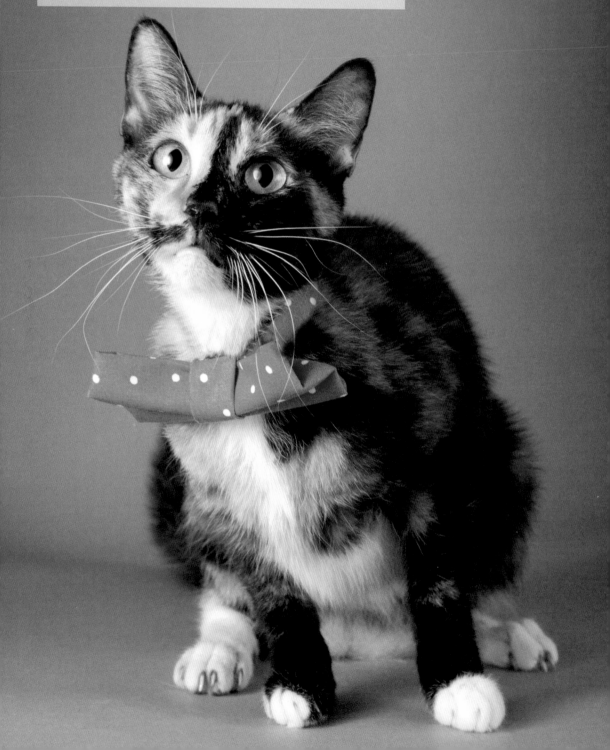

Jackie Flash

As her name suggests, Miss Flash is full of speed and energy. Each time I visit the shelter, she is the first to come running to me. She likes to ride on my shoulders, and sometimes, even on top of my head. She has fantastic balancing skills and would make a great circus cat.

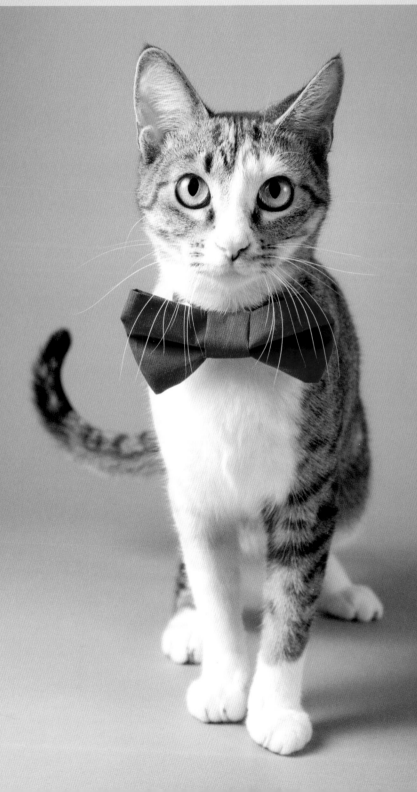

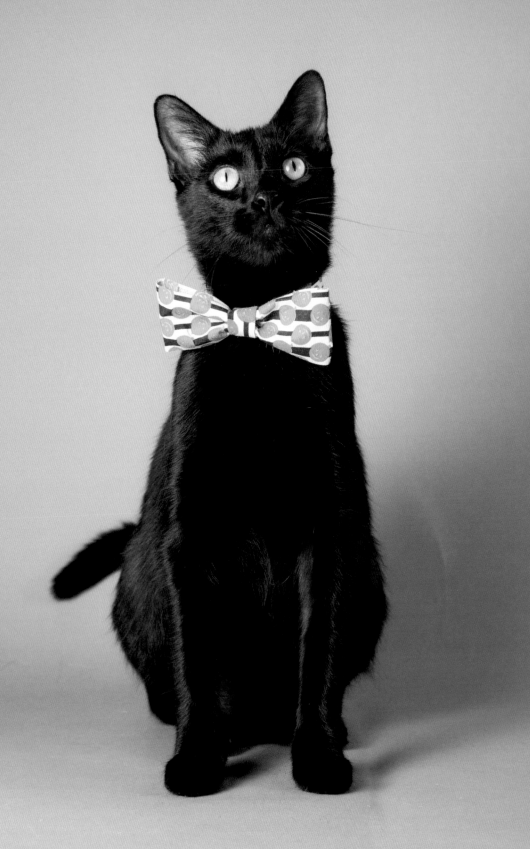

Pistol Pete

(*previous page*) Tall and sleek, Pistol Pete likes to rub on legs and is very loud and vocal. His striking golden eyes and proud stature are the epitome of a Halloween cat—hence the pumpkin-themed bow tie.

Jake

(*below*) Found as a stray kitten, Jake was cared for in a foster home until he was big enough to live with other cats in the shelter. You can find him at Miss Kitty, eagerly awaiting his forever home.

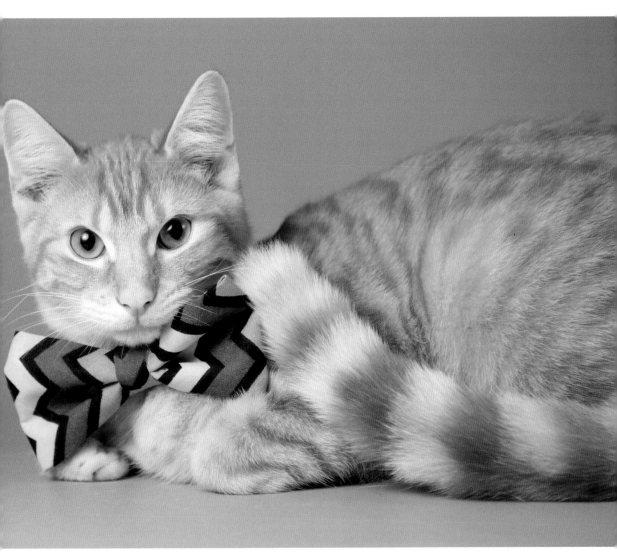

Piggy

Hyperactive and playful, Piggy is the type of athletic cat that can leap across rooms—and six feet into the air after a toy!

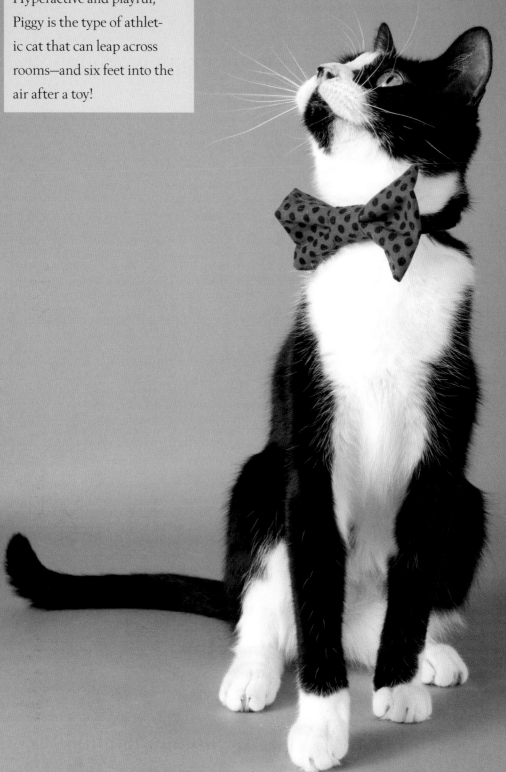

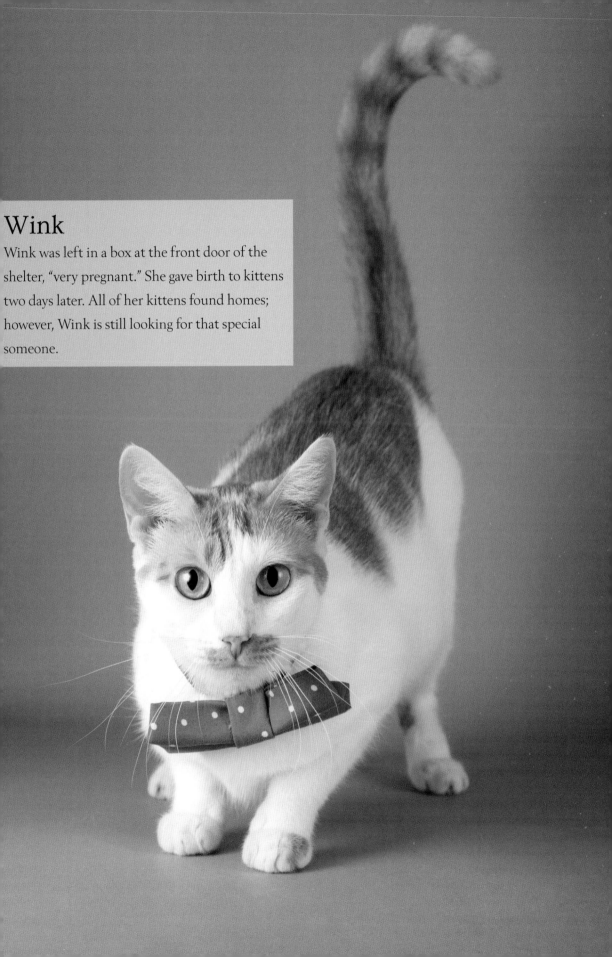

Wink

Wink was left in a box at the front door of the shelter, "very pregnant." She gave birth to kittens two days later. All of her kittens found homes; however, Wink is still looking for that special someone.

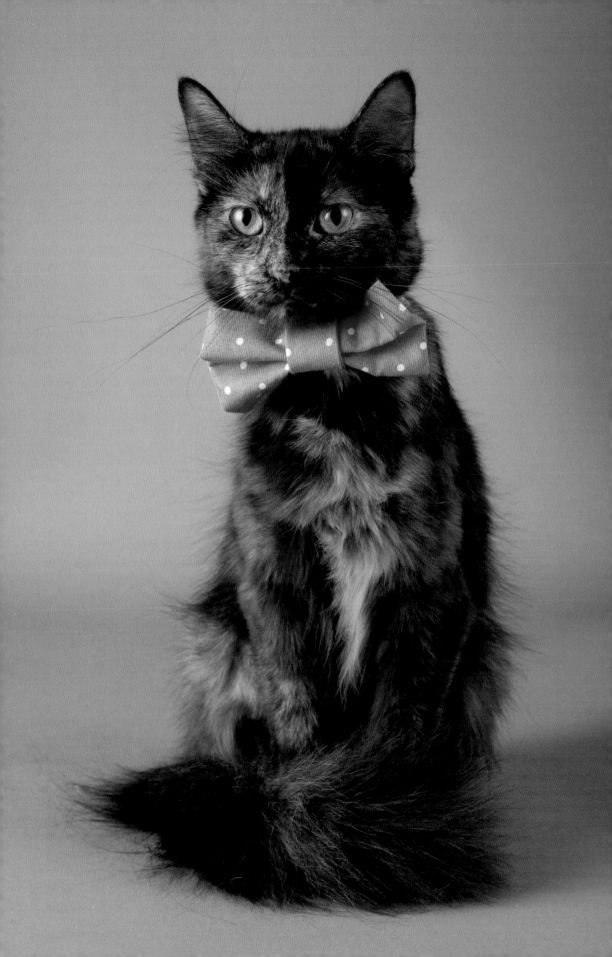

Clawdia

(previous page) With natural poise and incredibly soft, long fur, Clawdia was a proper camera-ready lady during her photo session.

Miss Hemingway

(below) Still awaiting a forever home, Miss Hemingway counts her days at the shelter on her extra toes. She is a polydactyl cat, meaning she has extra toes on her front and back paws.

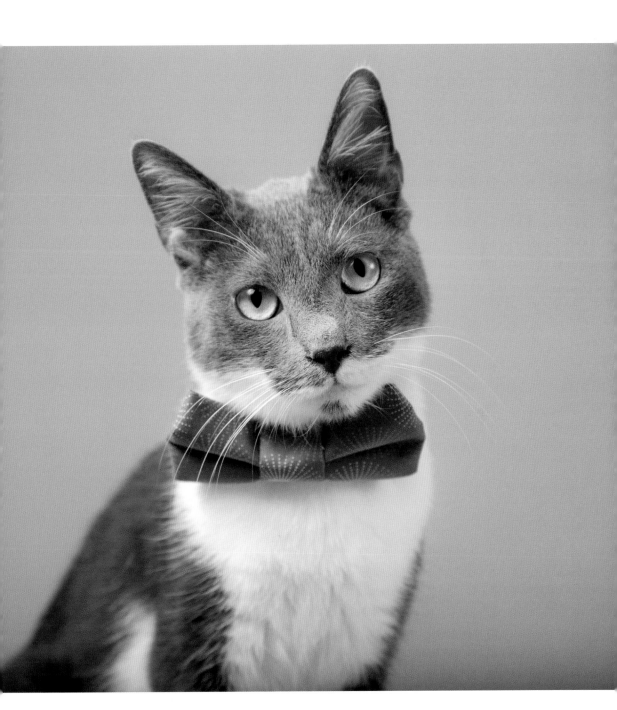

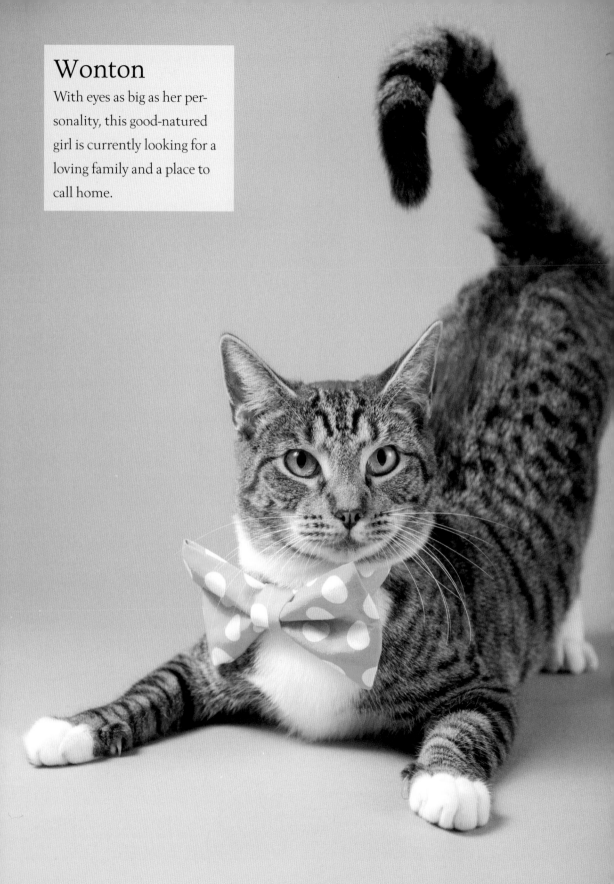

Wonton

With eyes as big as her personality, this good-natured girl is currently looking for a loving family and a place to call home.

Bailey

Often found purring and begging, Miss Bailey loves attention and petting. One morning, the shelter staff came in and saw her in the parking lot. When she saw the door open, she walked right in, where she found warmth, love, and a huge cat family.

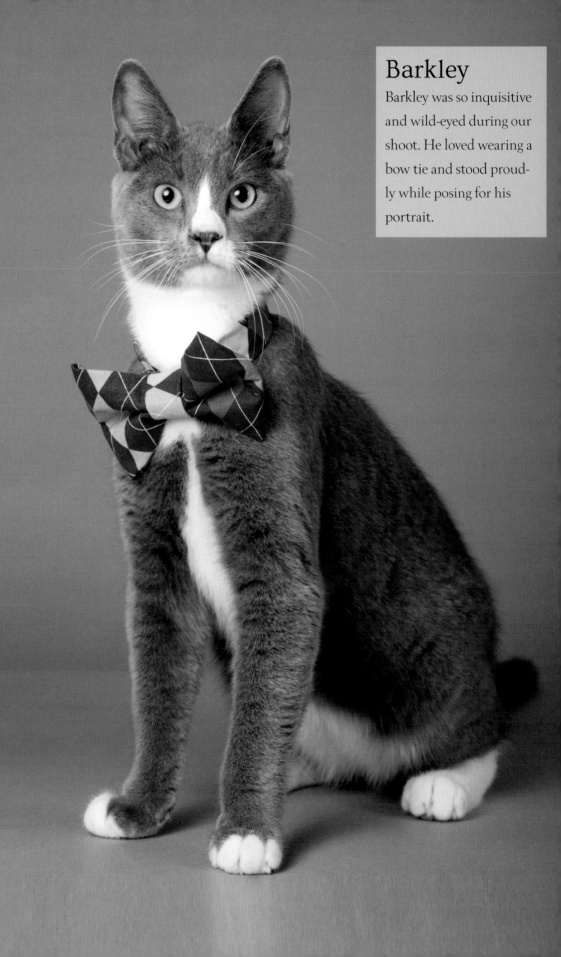

Barkley

Barkley was so inquisitive and wild-eyed during our shoot. He loved wearing a bow tie and stood proud- ly while posing for his portrait.

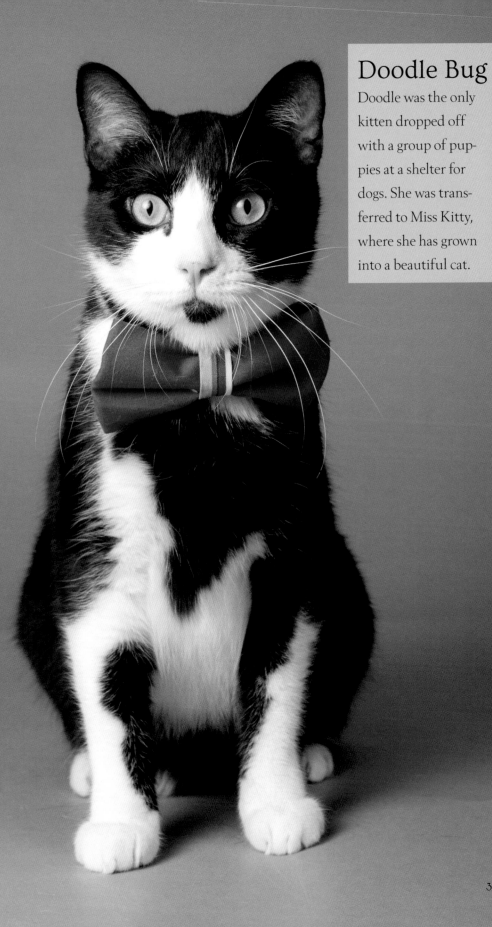

Doodle Bug

Doodle was the only kitten dropped off with a group of puppies at a shelter for dogs. She was transferred to Miss Kitty, where she has grown into a beautiful cat.

Sarah Louise

Sarah Louise was found as a kitten and delivered to Miss Kitty. She grew up in shelter care, and over time, has lost her teeth. She is still waiting her forever home.

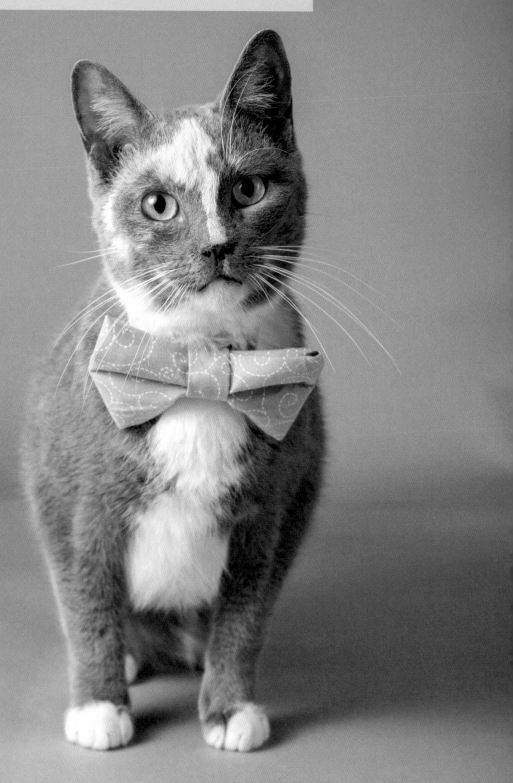

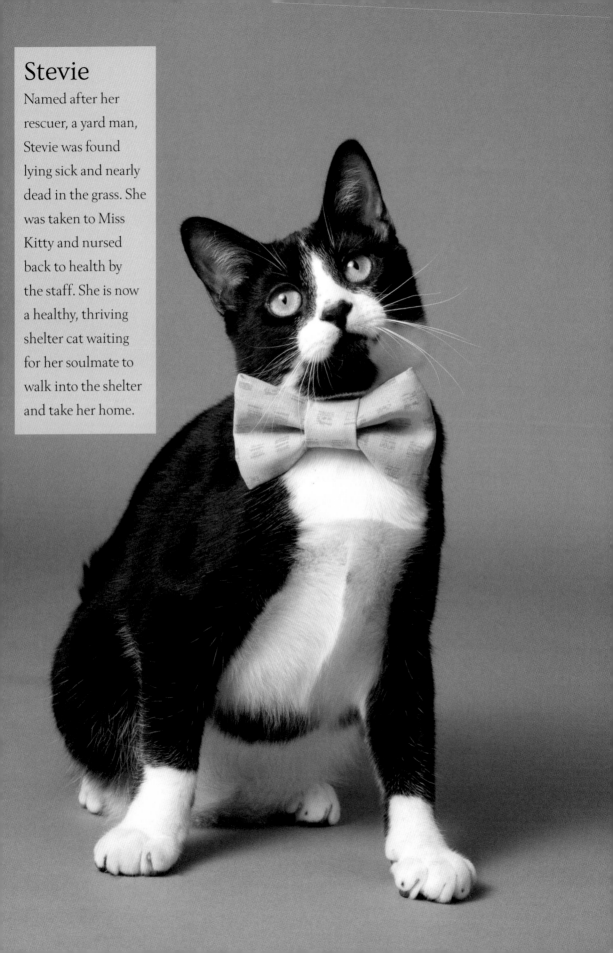

Stevie

Named after her rescuer, a yard man, Stevie was found lying sick and nearly dead in the grass. She was taken to Miss Kitty and nursed back to health by the staff. She is now a healthy, thriving shelter cat waiting for her soulmate to walk into the shelter and take her home.

Cherokee Rose

Found in a local park, Cherokee Rose had been chased up a tree by dogs. She was taken to the shelter, where she is waiting to be rescued again and taken to her forever home.

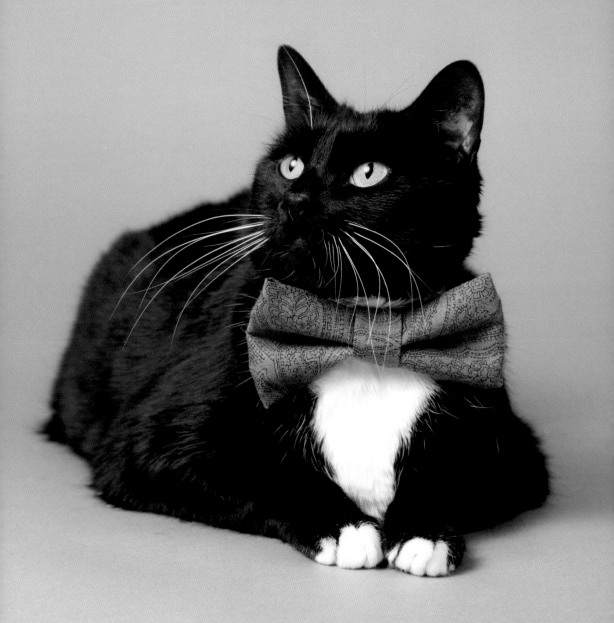

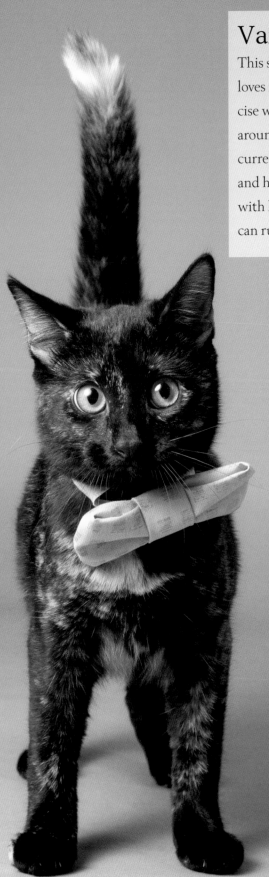

Vanna

This sweet tortoiseshell lady loves running on the exercise wheel and chasing toys around the shelter. Vanna is currently waiting adoption and hopes to find a home with long hallways that she can run up and down.

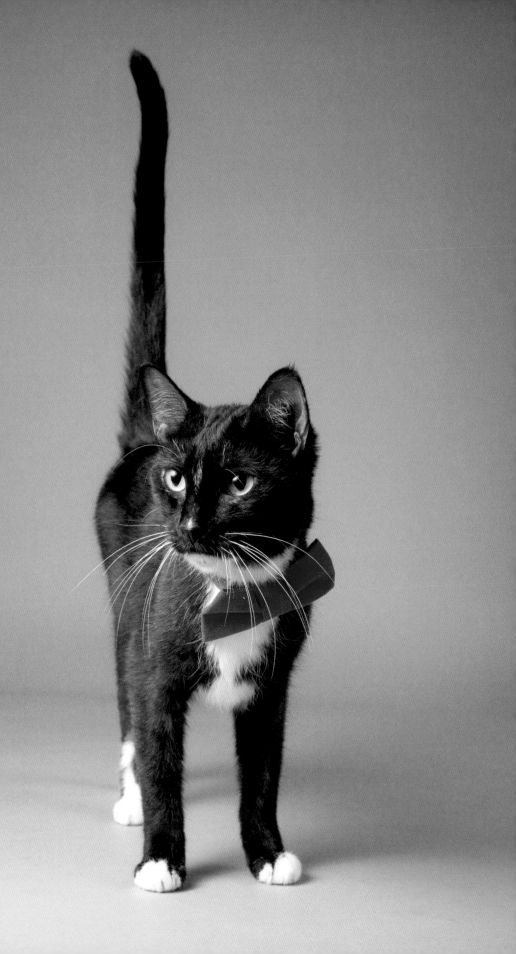

Kirby

(previous page) Kirby loves eating canned cat food and is currently conducting interviews for a human servant to feed and shelter him in exchange for love and playtime.

Kristoff

(below) Highly affectionate and full of mischievous glances, Kristoff was more interested in being petted and enjoying catnip while on set than having his photo taken.

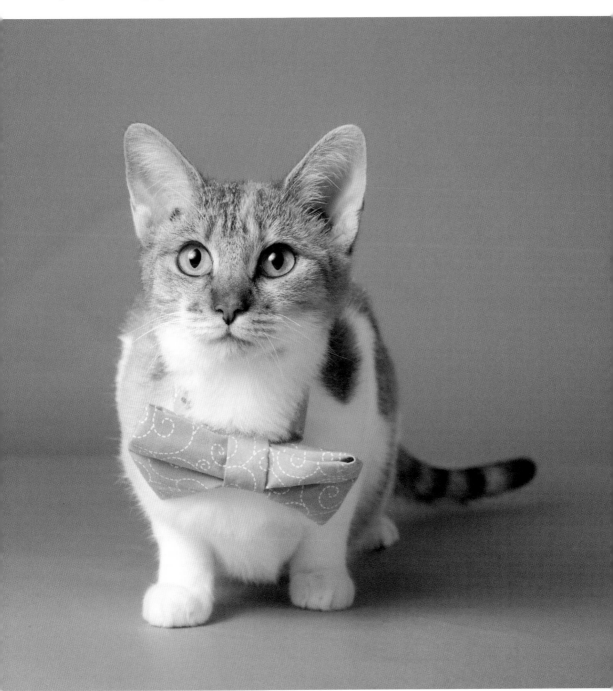

Amy

Amy made a home for herself behind a local pizzeria. She was mama cat to many litters, and all of her kittens were adopted. Amy ultimately found herself in shelter care and hopes to find a forever home for herself soon.

Nala

This sassy, striped kitty loved having her portrait taken. She indulged herself in the attention lavished upon her, and also the treats and catnip used on the set.

Zena

(below) Zena and her son were transferred from an overcrowded humane society to make a home at Miss Kitty. Her son found his forever home, but Miss Zena is still waiting for hers.

Ellie Mae

(following page) Like many shelter kitties, Ellie Mae was left at the front door of the shelter. Friendly and beautiful, Miss Ellie Mae dreams of having a home of her own with plenty of sunlight for afternoon naps.

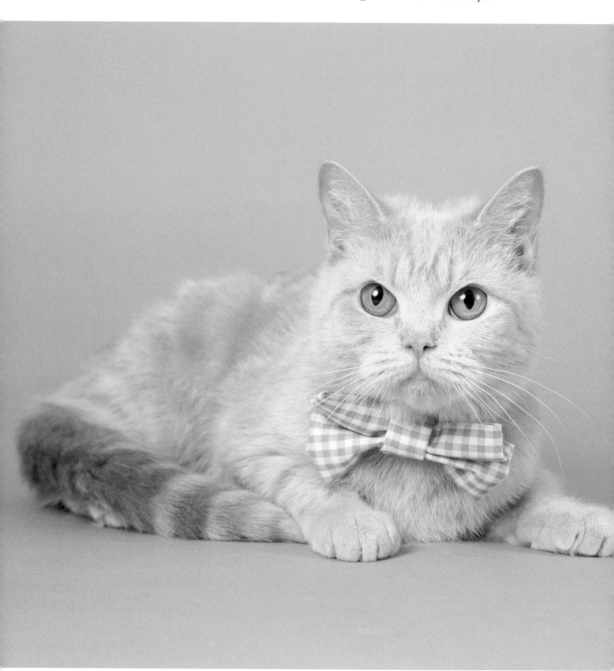

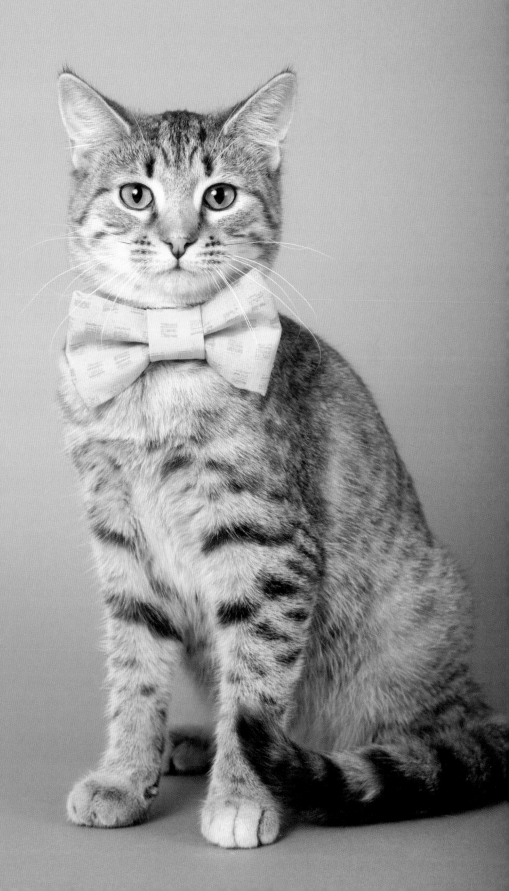

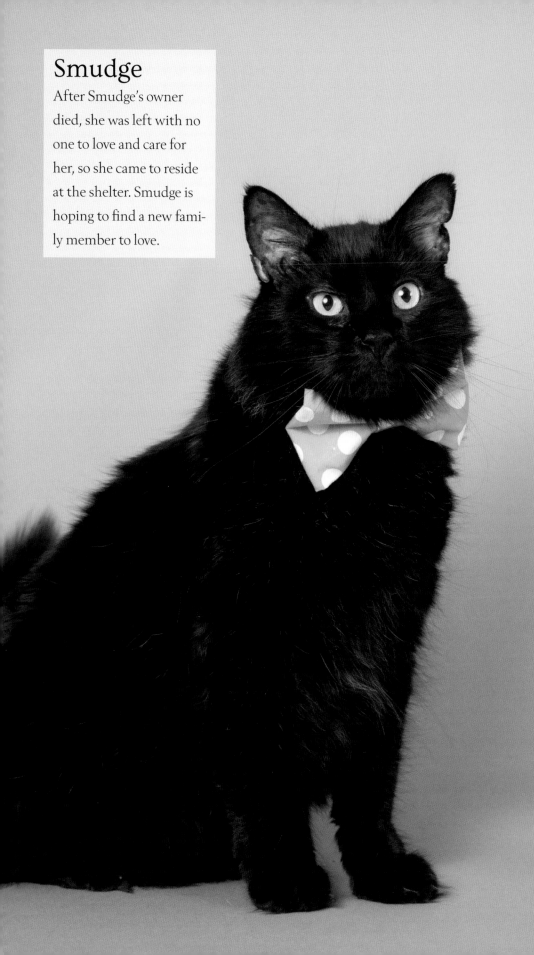

Smudge

After Smudge's owner died, she was left with no one to love and care for her, so she came to reside at the shelter. Smudge is hoping to find a new family member to love.

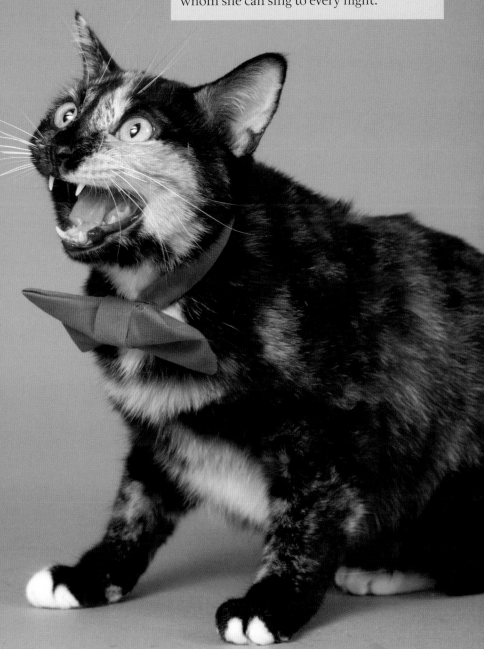

Susie Q

Vocal and friendly, this beautiful tortoise-shell girl was left in the parking lot of the shelter to fend for herself. She is often seen rolling around on the floor of the shelter. Susie Q is waiting for a loving human whom she can sing to every night.

Lori

(below) Lori was found living off scraps behind a local pizzeria. She is currently relaxing in the shelter, waiting for a fellow pizza lover to rescue her.

Lulu

(following page) Shy but soft, this beautiful gray tabby was born at the shelter and can't wait to get out into the world.

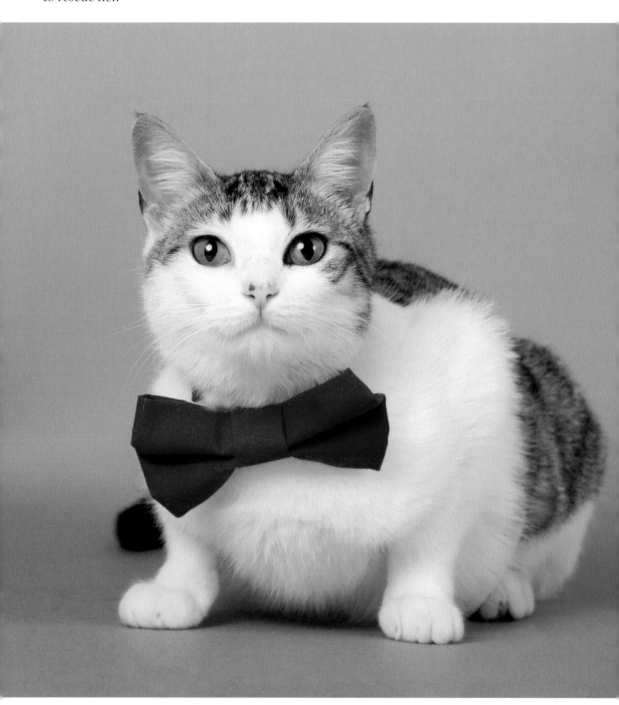

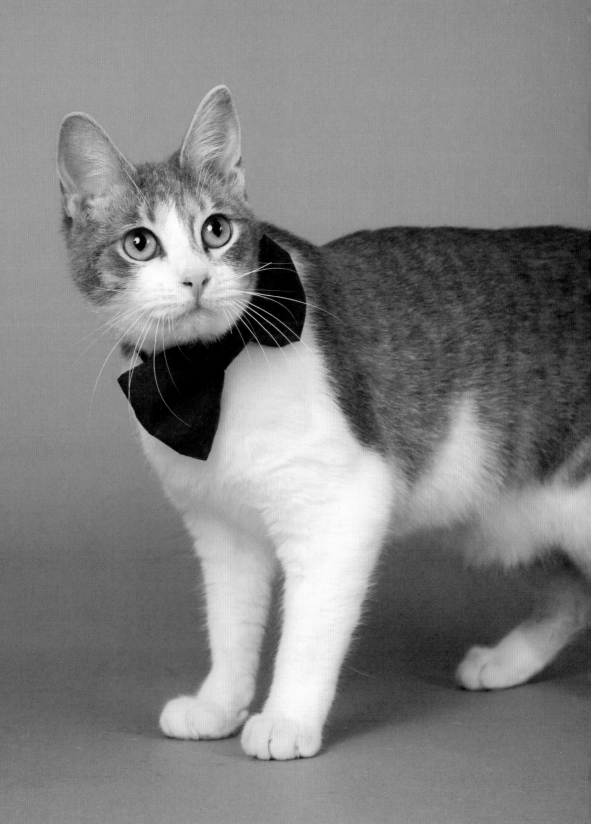

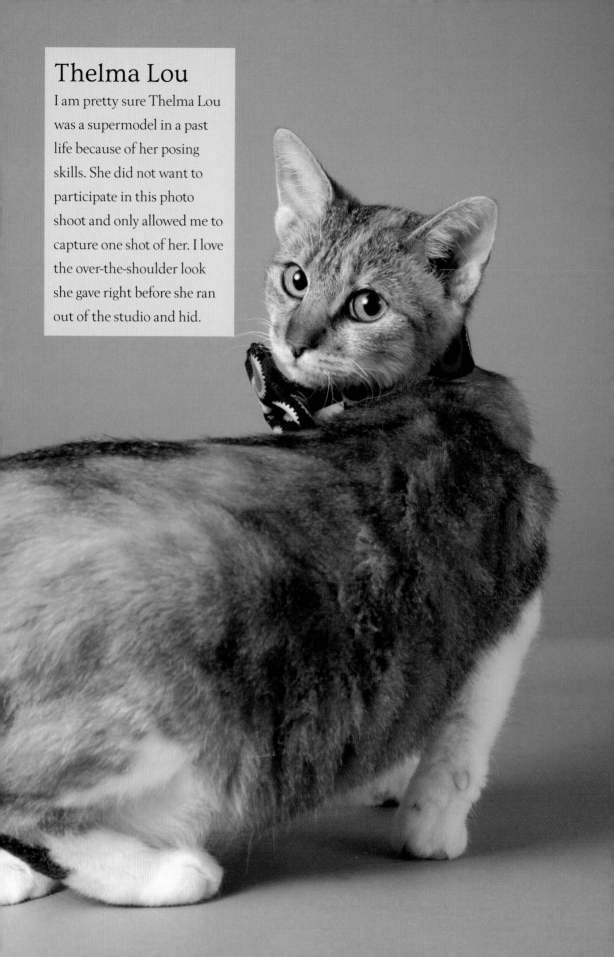

Thelma Lou

I am pretty sure Thelma Lou was a supermodel in a past life because of her posing skills. She did not want to participate in this photo shoot and only allowed me to capture one shot of her. I love the over-the-shoulder look she gave right before she ran out of the studio and hid.

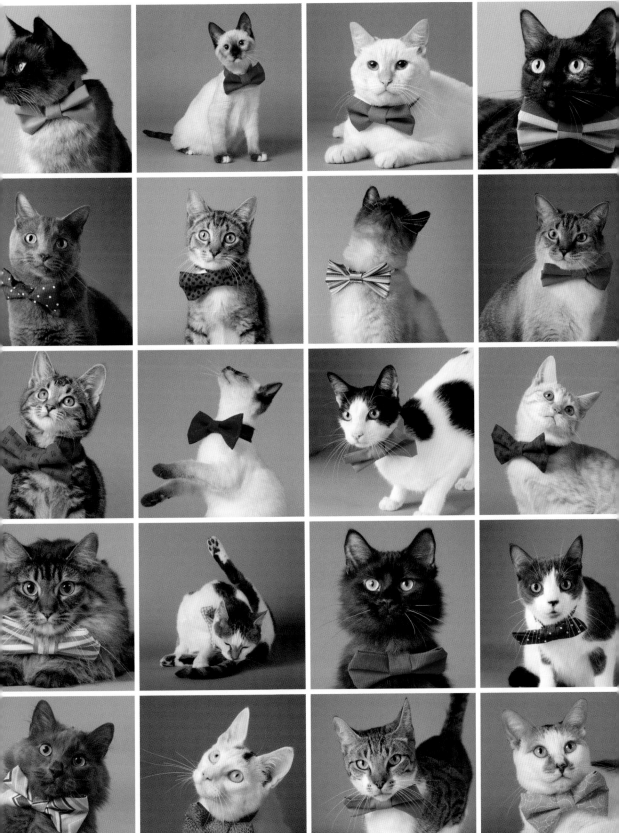

☻ Finally Home

Success Stories

Cats in this section have been adopted or were rescued by shelter volunteers. All of these cats found loving and happy homes with forever families. The best and happiest part of animal rescue is finding homes for pets in need. These cats represent success, love, companionship, and hope, inspiring their owners and setting an example of the happiness and love that can be found at an animal shelter.

"The best and happiest part of animal rescue is finding homes for pets in need."

Mama

(below) Mama came to Miss Kitty with her kittens. She lived with them in foster care until they all went to forever homes. After a short stay in the shelter, Mama was adopted due to her remarkably calm and soothing nature. She is now a full-time lap cat who can spend her hours purring and being loved.

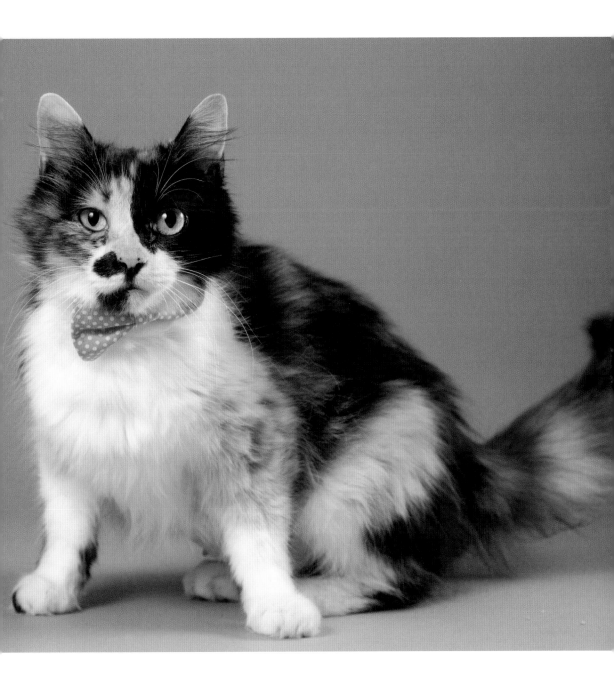

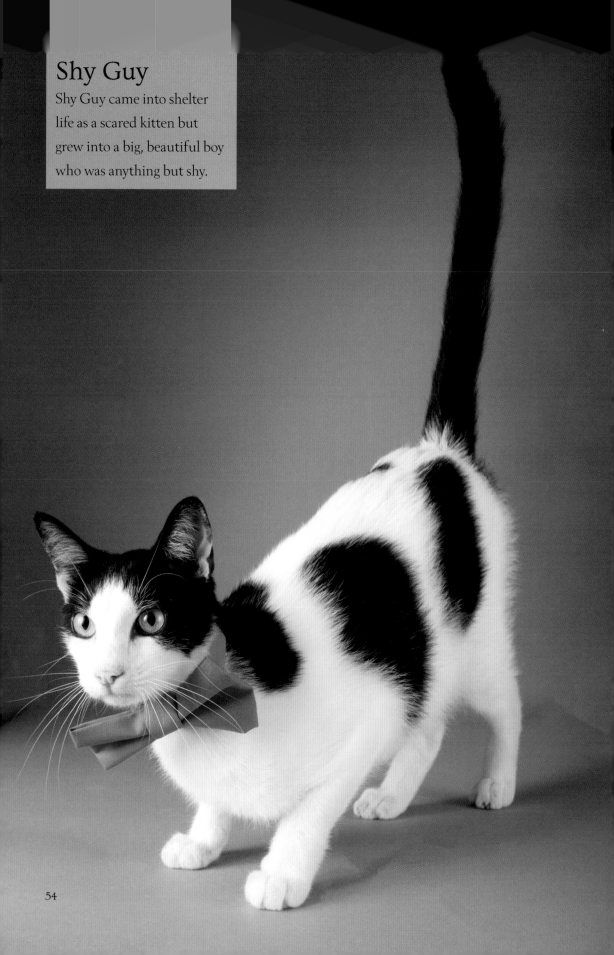

Shy Guy

Shy Guy came into shelter life as a scared kitten but grew into a big, beautiful boy who was anything but shy.

Helen Keller

Helen was found on the side of the road by a mailman serving his rural route. The tiny kitten looked to be in very poor condition, so he gathered her up and took her home to his wife. The couple soon realized this kitten's medical issues were beyond their capabilities, and she was taken to Miss Kitty and placed in foster care. She was extremely malnourished, loaded with parasites, and both of her eyes were severely infected. Over the weeks that followed, Helen made steady improvements. Her story was featured in the local newspaper, and shortly thereafter, a woman expressed interest in adopting her. She had a blind dog and several other handicapped animals and felt that Helen would fit right in. Over several weeks, the woman kept in touch with Helen's foster family; finally, she was cleared for adoption. Helen Keller healed and grew into a beautiful, fluffy, long-haired cat. Through her vet's expert care, she regained partial sight.

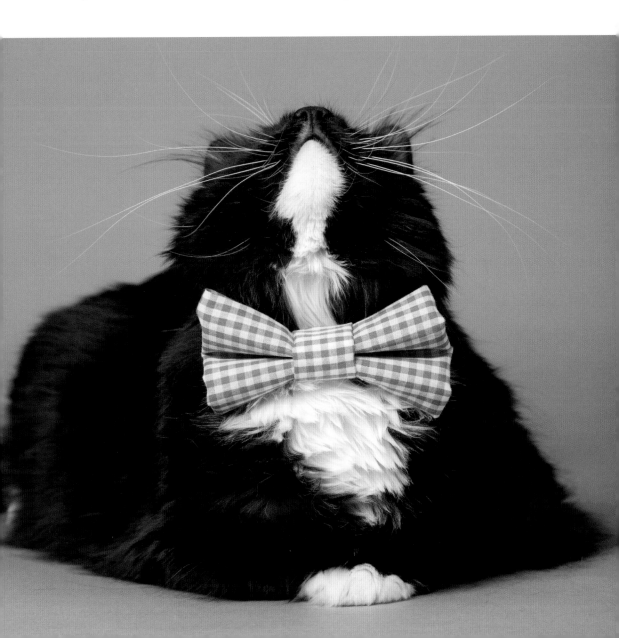

Sylvester

Sylvester is a large, solid, muscular shorthair with a calm demeanor. His big, beautiful yellow eyes and calming personality won us over during his photo shoot. He was adopted by my assistant and now enjoys lying around and watching TV.

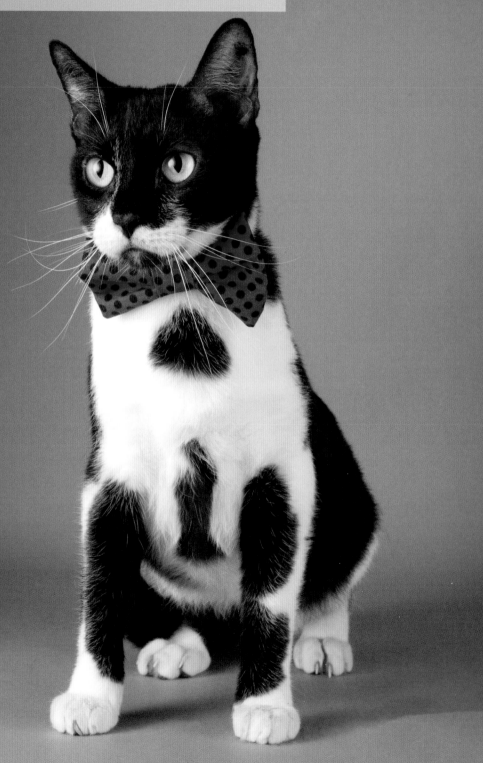

Bradford

Bradford was found by a longtime volunteer and current employee of Miss Kitty. While visiting her sister, she looked out of the window of the apartment and saw little Bradford hiding out in the drainpipe of a ditch. She slowly coaxed him out with food and captured the scared, hungry baby. Her parents encouraged her to surrender Bradford to the shelter; however, after a vet visit, it was found that Bradford had a fractured leg and would need extra care and physical therapy. The volunteer's family agreed to foster baby Bradford until he was healed, but after watching the compassion, care, and love displayed during his recovery, it was clear Bradford was meant to be her permanent companion. He lived a happy, well-cared-for life with his rescuer.

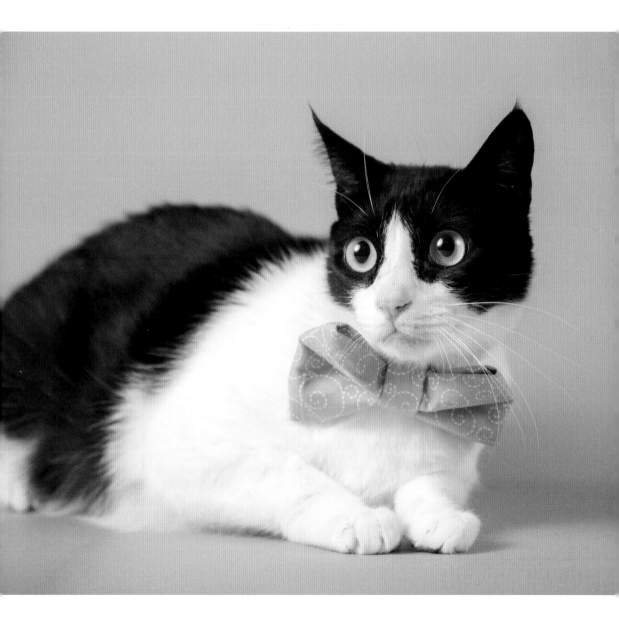

Pogo

(below) Pogo spent his life in and out of shelter care. He entered the shelter as a kitten with his mother. They were both adopted into different homes; however, Pogo was returned due to allergies. After another year in shelter care, Pogo finally found an allergy-free forever home.

Skittles

(following page) Mr. Skittles spent the first six years of his life in the shelter, until the happy day his soulmate came in and fell in love with the 12-pound, green-eyed, mini panther. Skittles now lives happily with a family of dogs and cats and is reported to be the entertainer of the group.

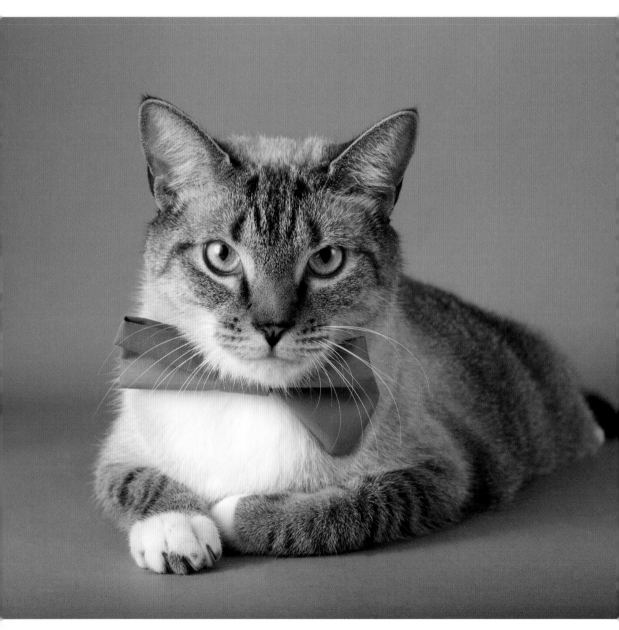

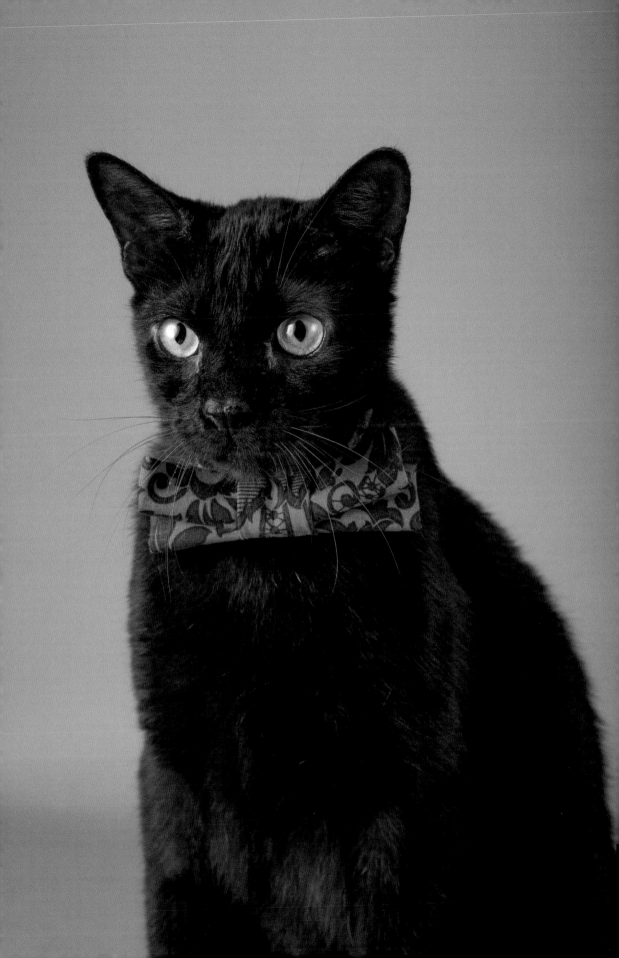

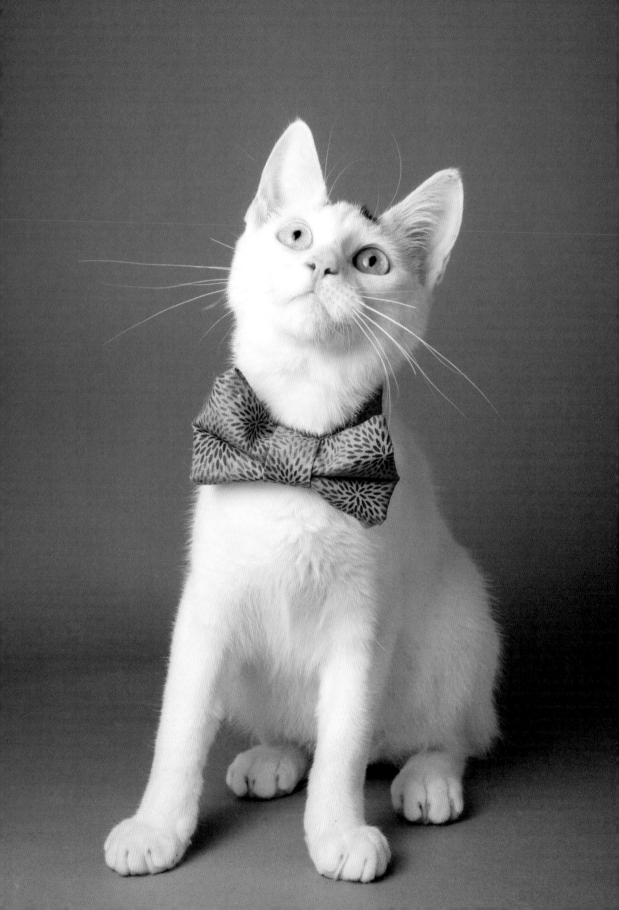

Banjo

(previous page) Banjo's stunning white fur and unique eye color made him stand out. He was the only kitten in his litter to have such exceptional eye color.

Cheeto

(below) This orange four-legged fuzz ball loved wearing his bow tie and prancing around.

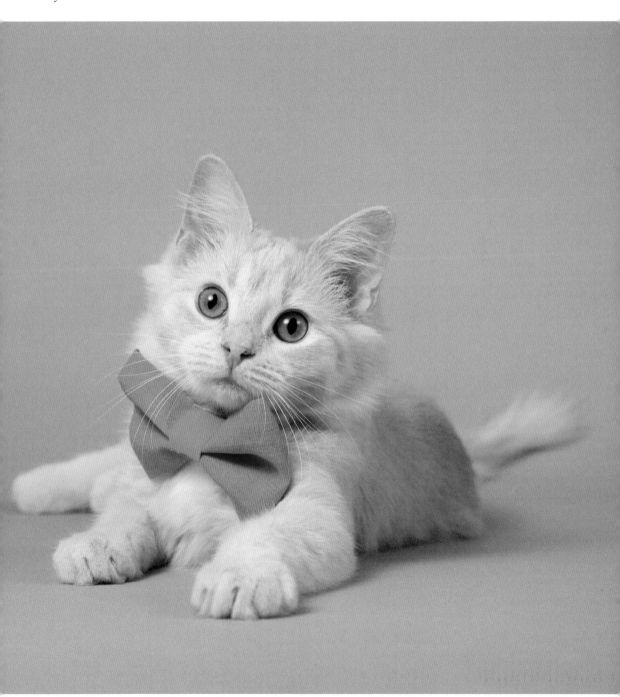

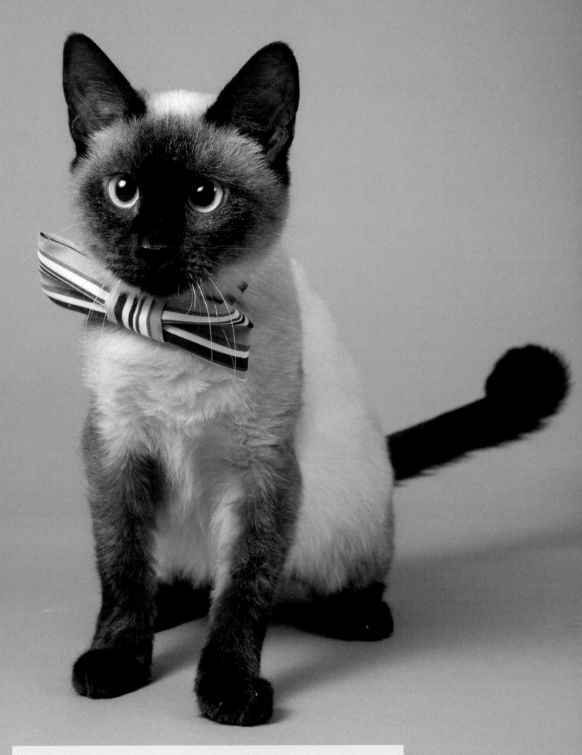

Thea

An extremely shy Siamese, this beautiful blue-eyed kitty hated shelter life. She was allowed to live alone in a bathroom until she was adopted. Thea has now come out of her shell and is thriving in her new home.

Ralph

Ralphie's cute, playful nature and soft, ginger fur won the hearts of a wonderfully fun family. Not much of a snuggler, Ralph prefers to play and chase his toys. He is very happy in his new home.

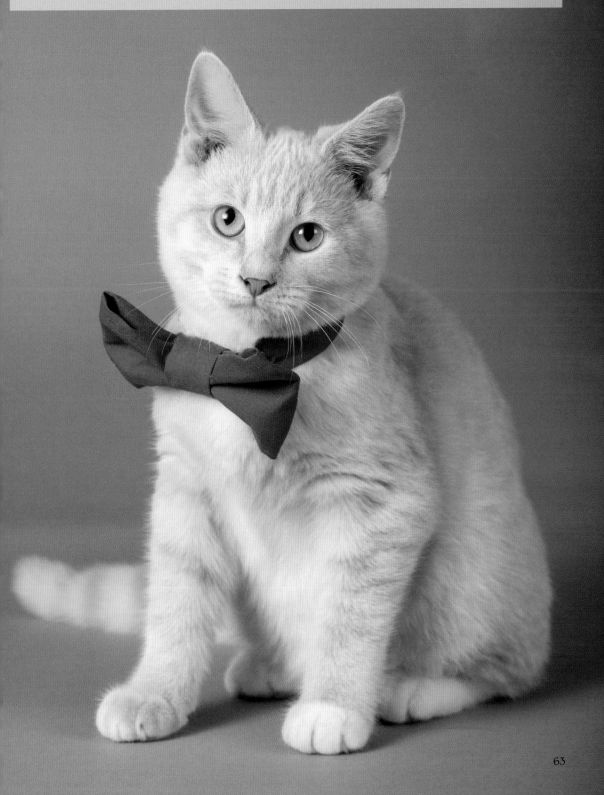

Radar

(below) Radar has the softest fur and sweetest little personality. It's no wonder he was adopted very quickly.

Spot

(following page) Spot was one of my favorite cats in this series. He was incredibly affectionate. When I visited him at the shelter, he would leap from the floor into my arms and cover me in kisses.

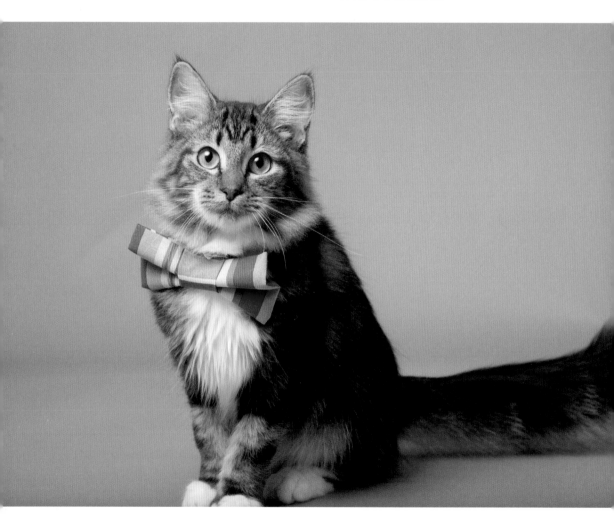

"Spot was one of my favorite cats in the series."

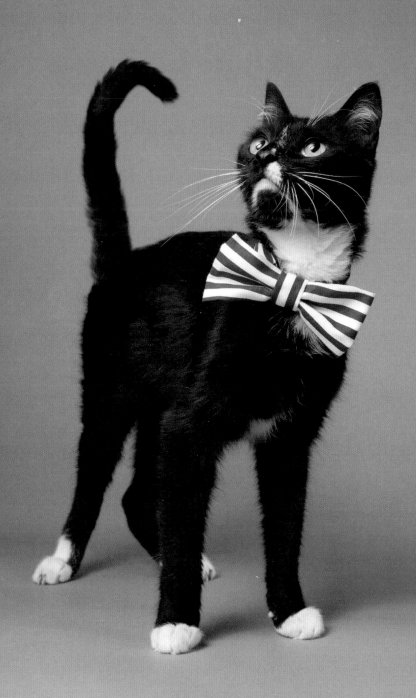

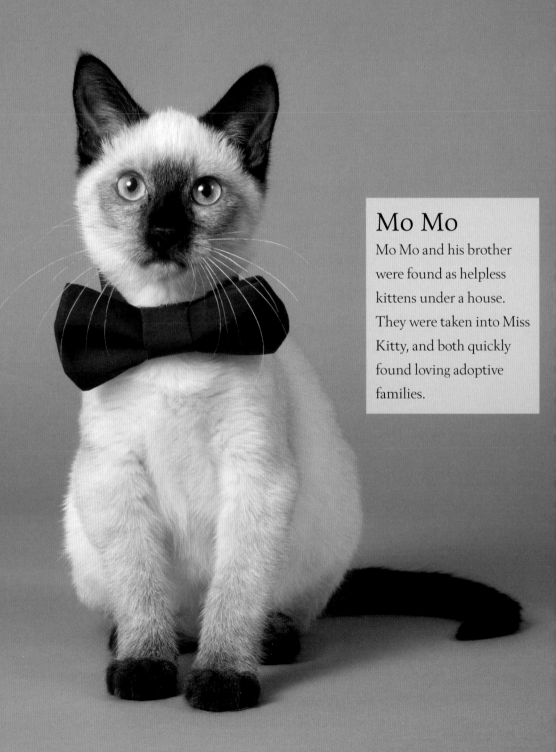

Mo Mo

Mo Mo and his brother were found as helpless kittens under a house. They were taken into Miss Kitty, and both quickly found loving adoptive families.

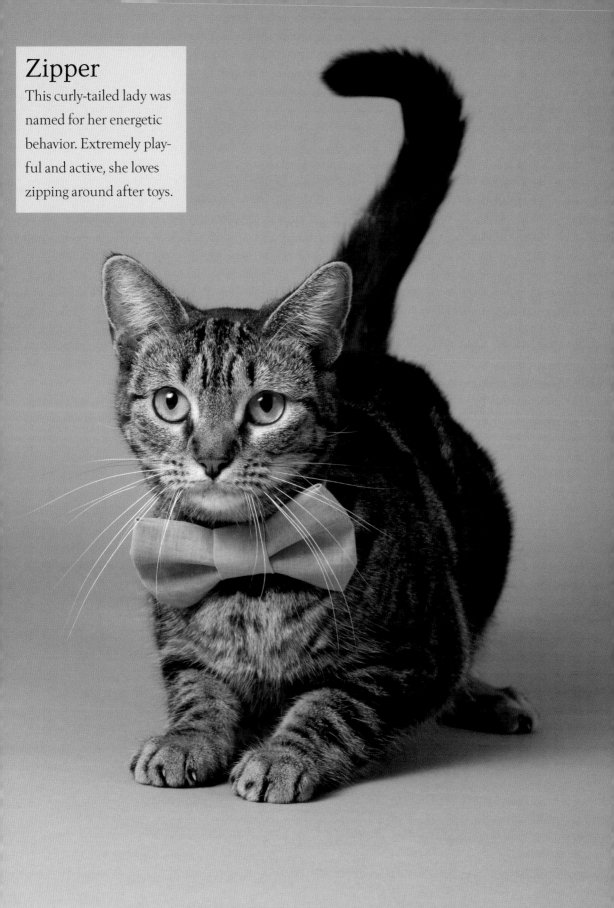

Zipper

This curly-tailed lady was named for her energetic behavior. Extremely playful and active, she loves zipping around after toys.

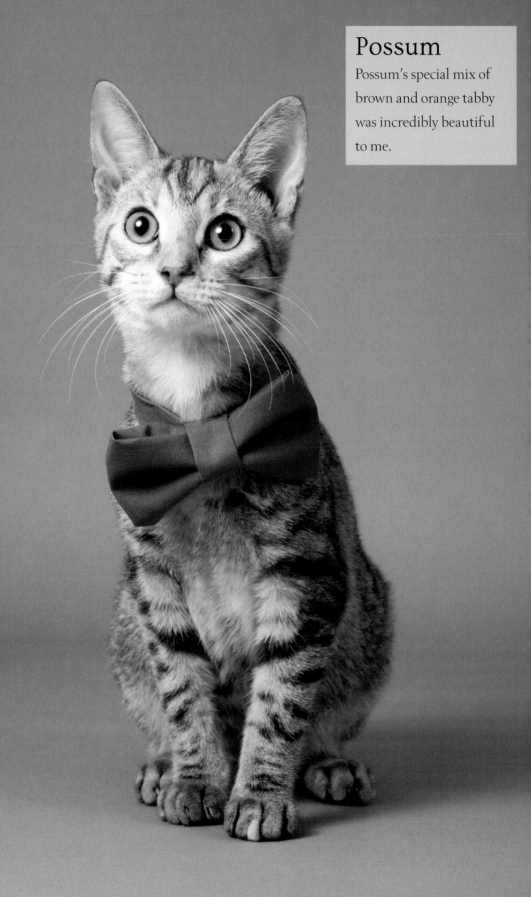

Possum

Possum's special mix of brown and orange tabby was incredibly beautiful to me.

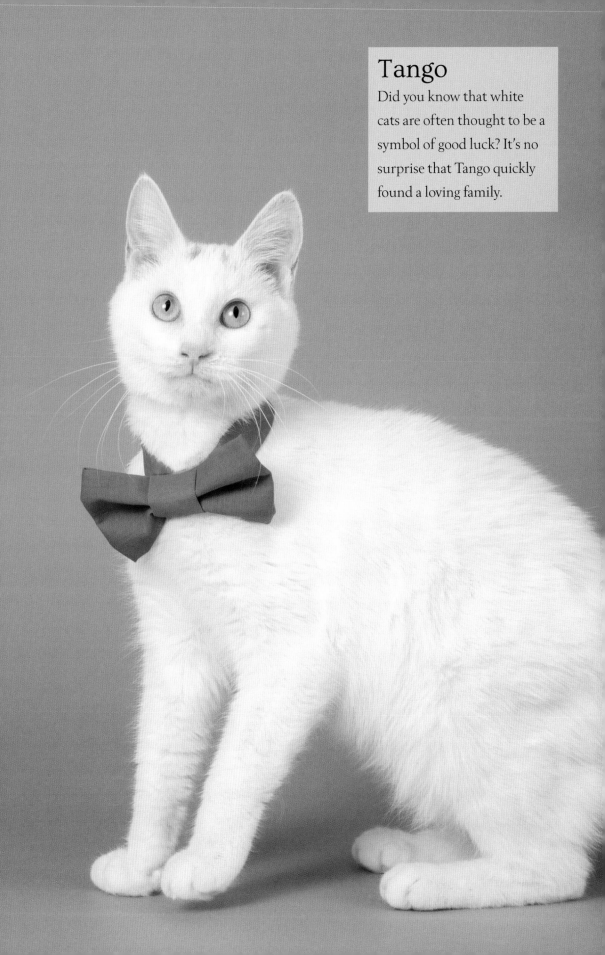

Tango

Did you know that white cats are often thought to be a symbol of good luck? It's no surprise that Tango quickly found a loving family.

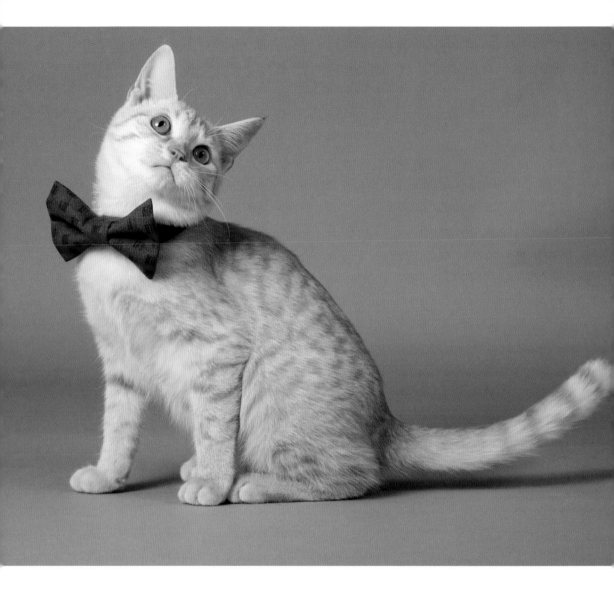

Maude

(*above*) I loved the color combo of Maude's beautiful orange fur and the deep purple of the bow tie she wore for her portrait.

Danica

(*following page*) As a kitten, this lovely gray tabby zoomed around the shelter and did everything at full speed, so a volunteer named her Danica (after the former race car driver).

A few months after meeting this sweet baby, the woman returned to the shelter to find that Danica had grown into a beautiful long-haired cat. The volunteer and Danica were reunited, and she knew right away that Danica was meant to join her family.

Danica now spends her time curled up by the fireplace or sitting by the window, chirping at passing hummingbirds.

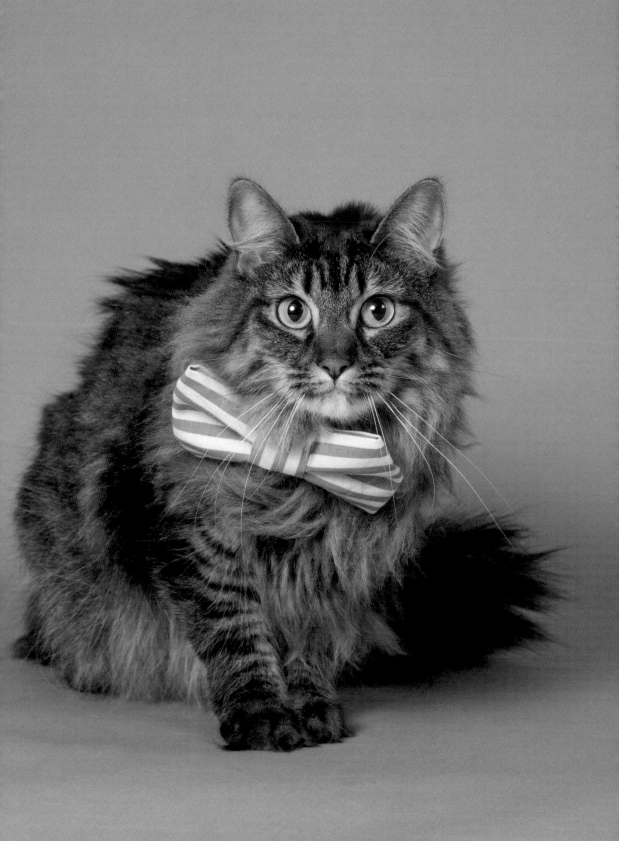

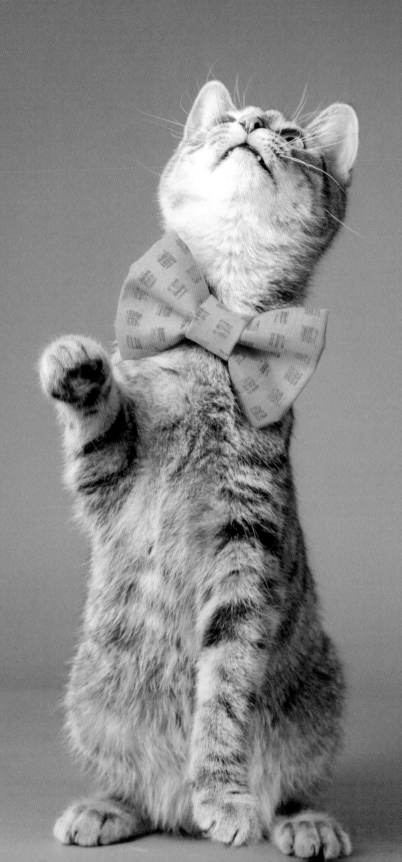

Boss

(previous page) Bright-eyed and energetic, this youthful feline was thrilled with the attention, extra playtime, and new toys he experienced during his photo shoot.

Rudolf

(below) This tiny gray fluff ball grew into a massive longhaired lover boy. Rudolf loves to take naps by the window and enjoys belly rubs.

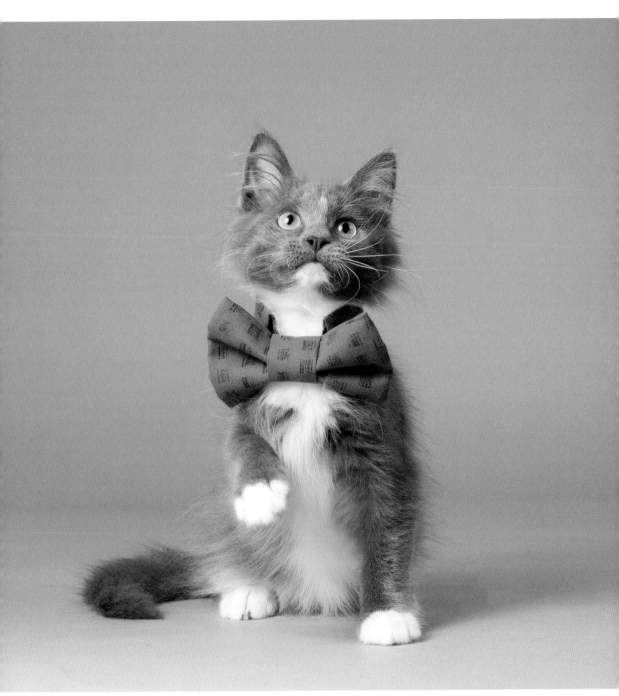

Miso

(*below*) Miss Miso had a thunderous purr and loved to be held. She thrived on receiving affection and really enjoyed the treats she received during her photo shoot.

Miss Metcalf

(*following page*) The distinctive gray stripes on this frisky little tabby reminded me of a wild tiger.

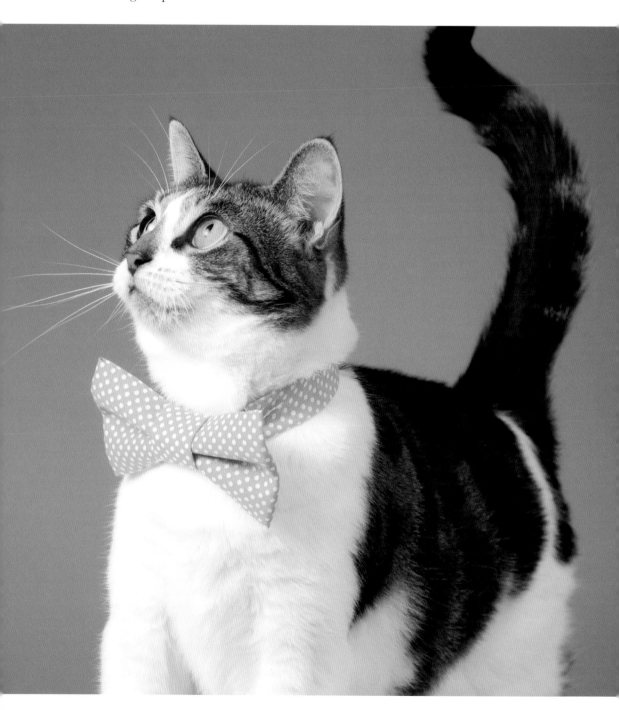

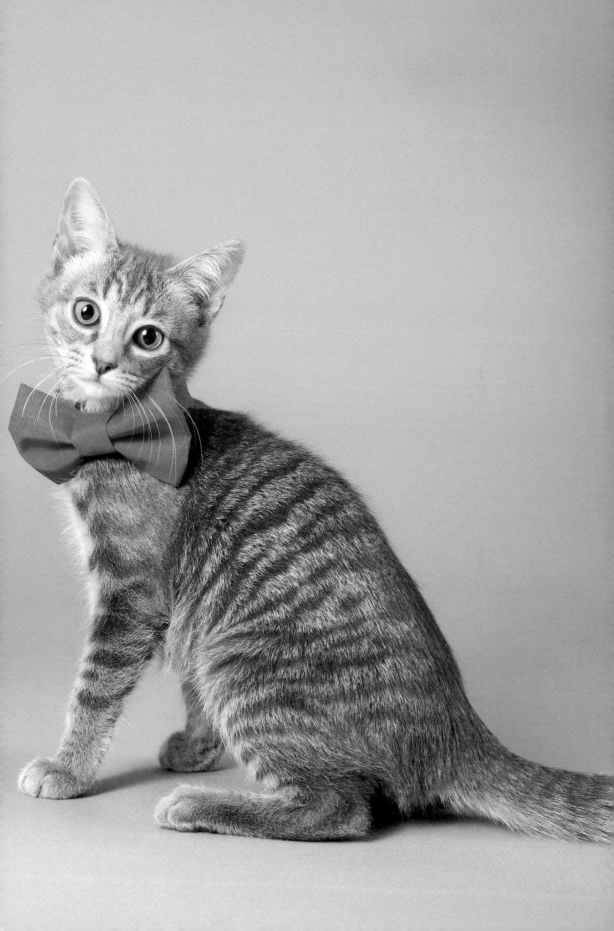

Elf

(below) Muscular and ready for action, Elf was a very playful young cat. All she wanted to do was play with toys. Elf was adopted by a family with a young boy. She and her companion now enjoy their days playing together.

Kringle

(following page) Kringle's spotted belly was so adorable, I felt I had to highlight it in his portrait.

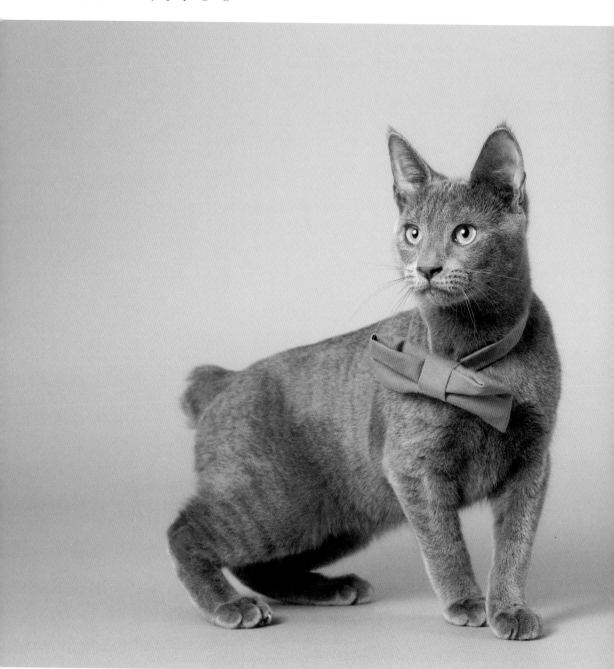

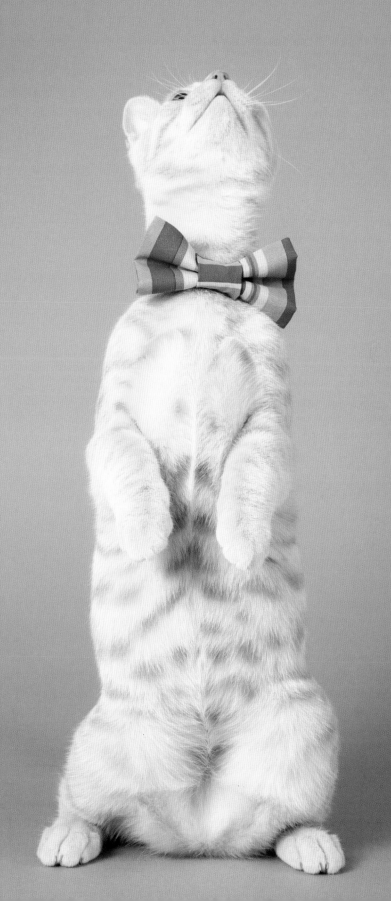

George

(below) George's cute little pink nose, fluffy mane, and white-tipped tail made him an irresistible choice for adoption. He now enjoys endless belly rubs and loves riding in the car as a copilot on long road trips.

Gamma

(following page) This intelligent feline was so inquisitive during her photo shoot. I could tell she was genuinely interested in what was going on behind the camera. She may make a great photographer's assistant one day.

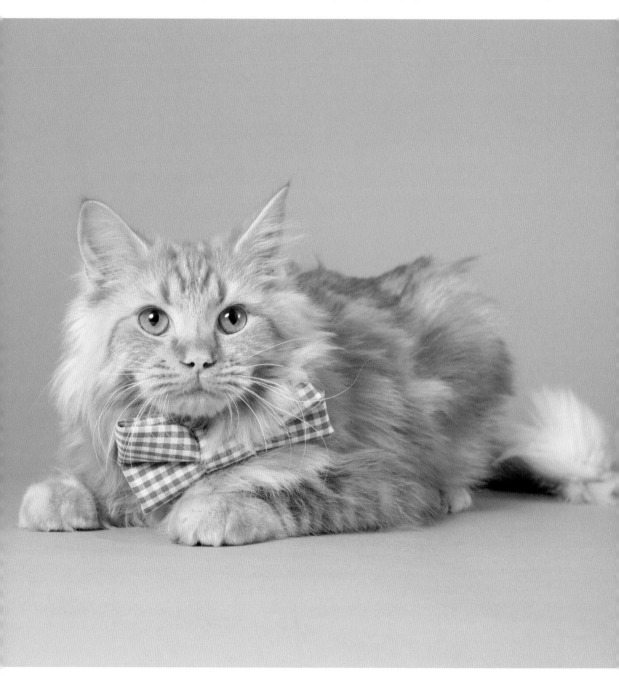

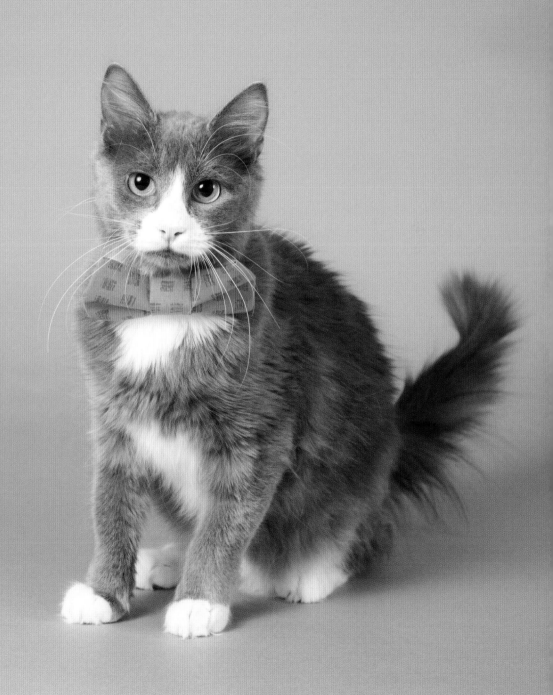

Sheldon

(below) Bright-eyed and bushy-tailed, this adorable tabby sweetheart had an incredibly loud purr.

Jareth

(following page) This blue-eyed baby won our hearts during his photo shoot. A few weeks later, my assistant and I returned to Miss Kitty, and she adopted him. Jareth loved to play games like fetch and chase-the-laser-pointer.

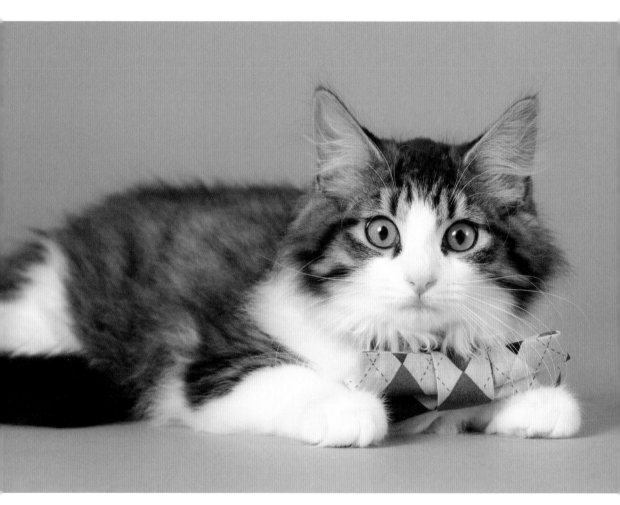

" . . . this adorable tabby sweetheart had an incredibly loud purr."

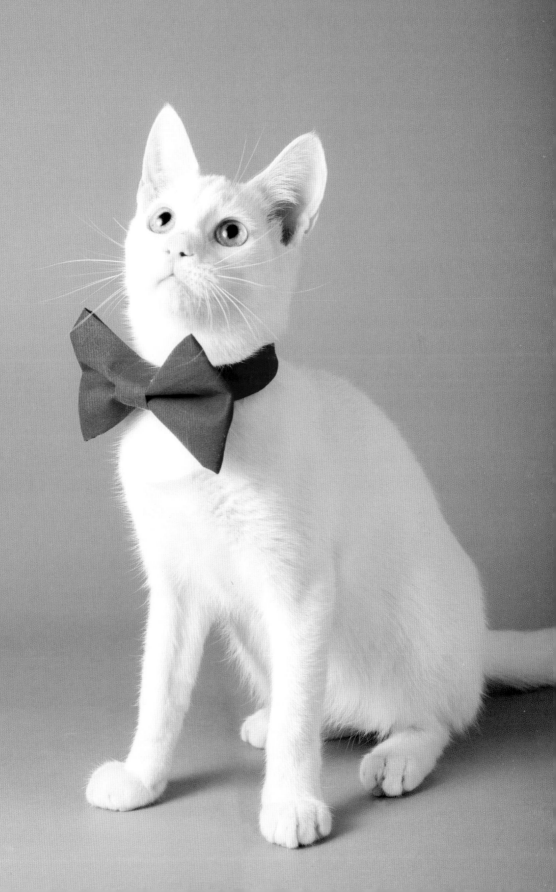

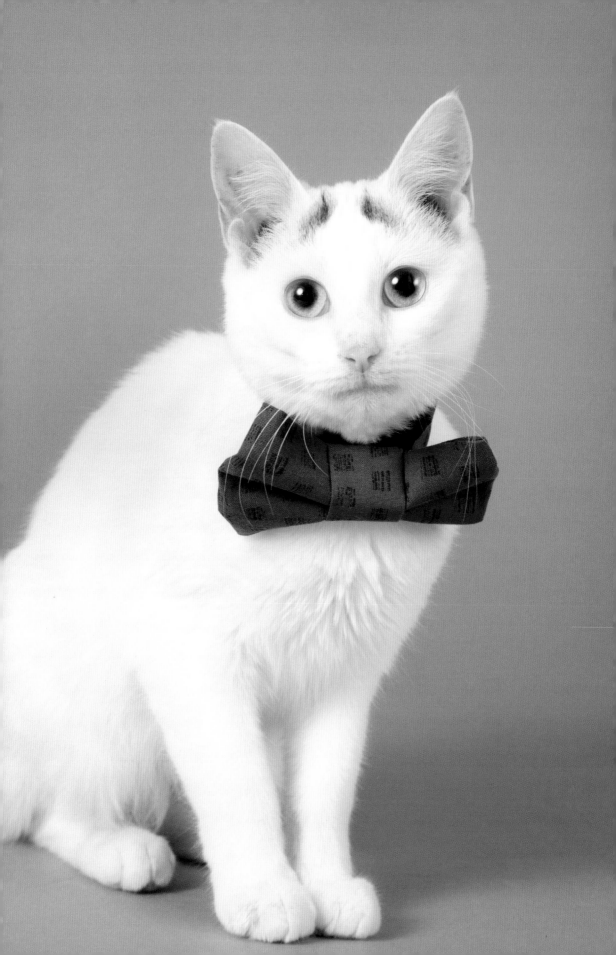

Serena

(previous page) Serena's stunning blue eyes and distinctive eyebrows set her apart from the other cats at the shelter when her adopter came to visit. Serena now spends her days watching the fish tank and racing around the house each morning when she hears the alarm clock.

Oscoe

(below) Oscoe likes to be in the middle of everything, including helping to prepare family meals. He seems to think it's alright to hang out on the kitchen counter to see what he can sneak as a treat. Loving and affectionate, Oscoe adores giving kitty hugs and kisses.

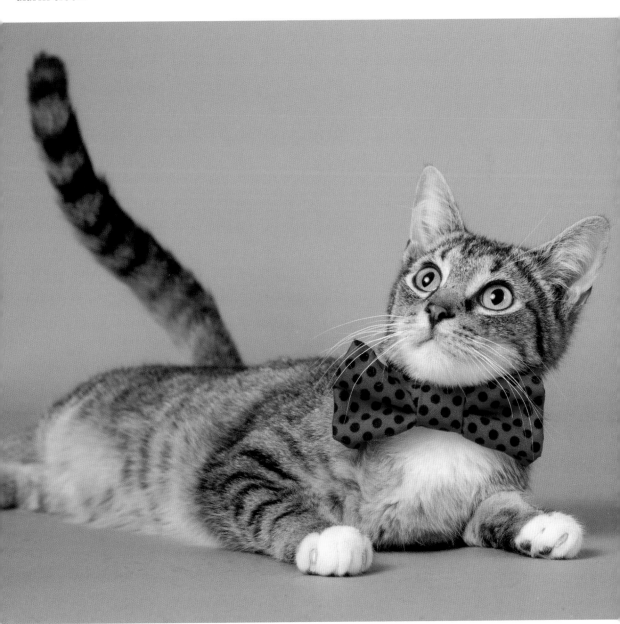

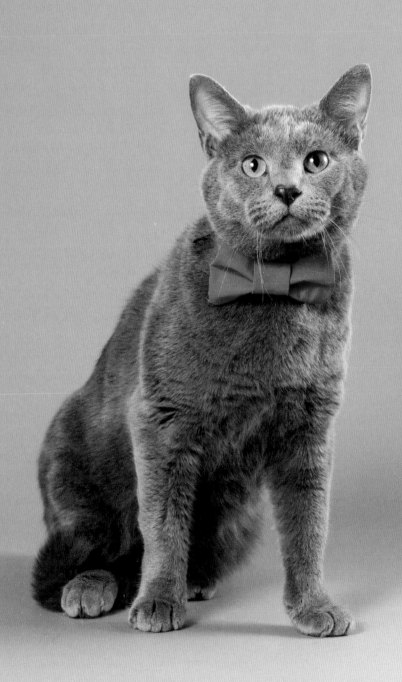

Beldar

(*previous page*) This animated feline is always up to something. Beldar loves to run through the house and play tag with his humans or ride around on their shoulders. He has been caught on multiple occasions stealing French fries and bags of potato chips from the kitchen. He loves to steal hearts, too.

Evie

(*below*) Evie enjoys a lavish diet of seafood and gravy, lovingly prepared by her human caretakers. She is living the life of a pampered rescue cat in her new home. She and her new sister, also a rescue cat, love chasing each other around the house and stalking bugs.

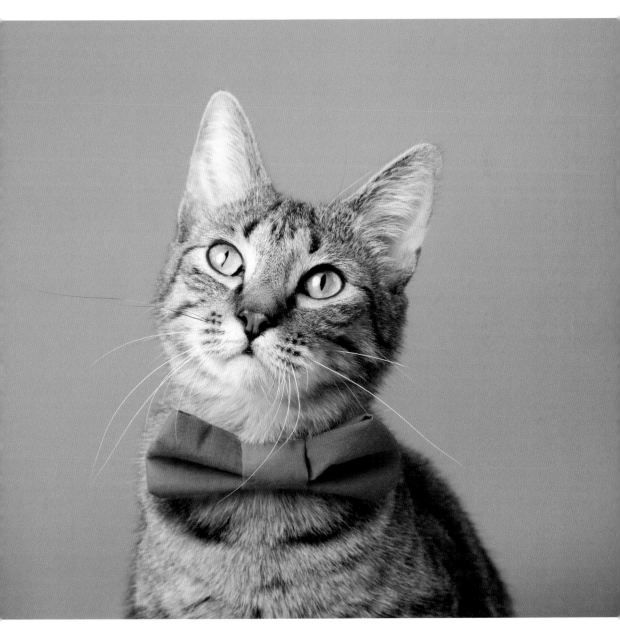

Fluffy

Named for his long, flowing fur, Fluffy was found in the middle of a road with a broken leg as a three-month-old kitten. His future adopter agreed to temporarily foster him until his leg healed; however, due to infection and other complications, the leg needed to be removed. After nursing him through the healing process, his foster mom was hooked and decided to make him a permanent member of the family.

Working Cats

Special Talent

Cats are amazing companions at home and at work. The kitties in this section have been adopted and now help their humans in a professional environment. From creative inspiration to emotional support, they make the workday pass much faster.

"The kitties in this section have been adopted and now help their humans in a professional environment."

Roxy

Roxy came to Miss Kitty as a kitten. She grew up at the shelter, and upon reaching adulthood, suddenly began having problems walking. She required expensive surgery, which was paid for through donation. She needed to be watched closely during recovery, so she was brought into the office, where she has been ever since.

Roxy is now the official office manager at Miss Kitty. She spends her days sitting at a desk, greeting visitors, socializing with volunteers, providing a source of comedy, and inspecting anything and everything that goes in or out of the Miss Kitty office door.

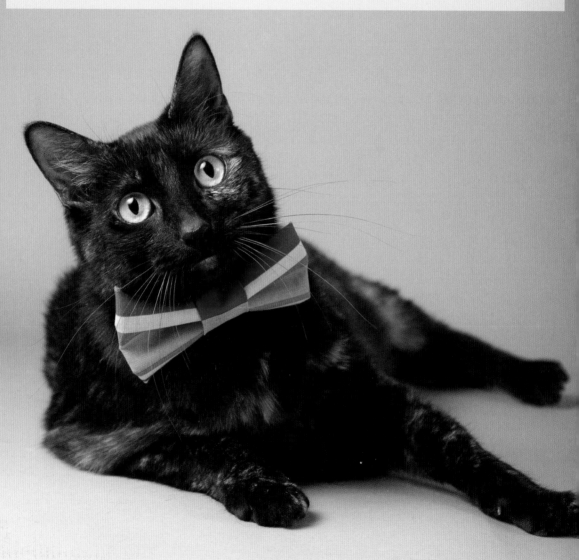

Zero

It was love at first sight when I laid eyes on Zero. He was such a sleepy, laid-back kitten; he passed out in my arms the first time I held him. I made my first bow ties for Zero, and he posed for my first Cats in Bow Ties portraits. Zero oversaw the making of and tried on most of the bow ties used in the project. He slept on my pillow for 14 years and was my best friend.

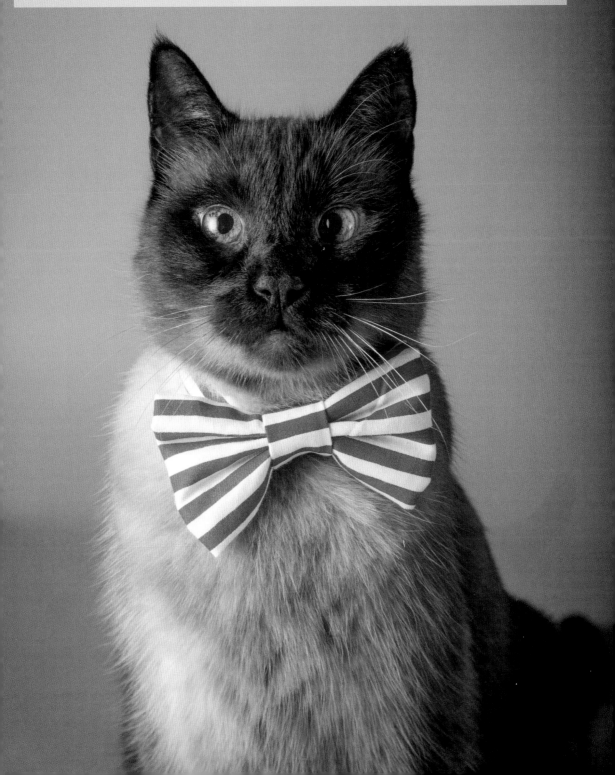

Madame Cleo

My husband and I spotted this beautiful kitten jumping out of a car wash trash can. She made eye contact with us from across the parking lot and came running to our car. He opened the car door, and she jumped in, rubbed all over both of us, and sat down in my lap. We decided then and there that she would become a part of our family.

Madame Cleo now spends her spare time sitting on my desk, supervising as I write and edit my work.

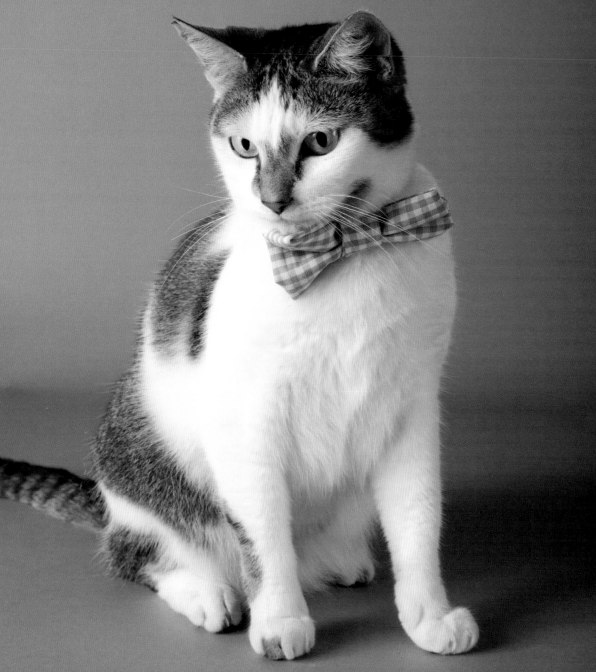

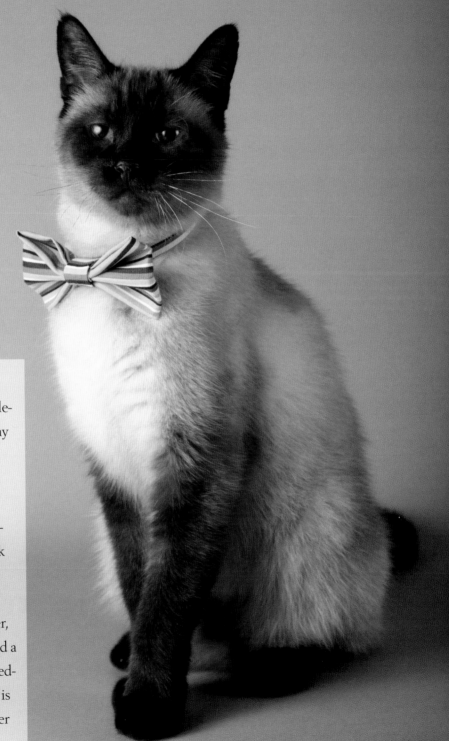

Sam

This sophisticated gentle-
man lived with me as my
college roommate and
modeled for me while I
learned to draw, paint,
and become a photogra-
pher. He sat on the back
of my desk chair and
oversaw my work as I
graduated, built a career,
got married, and created a
happy life. He was incred-
ibly loved for years and is
a deeply missed member
of our family.

Zookie

(*below*) I adopted my Zookie after the passing of my beloved Sam and Zero. This adorable snowshoe cat sat on my desk and oversaw the entire writing process of this book. She loves to carry toys around in her mouth and enjoys taking a ride in the stroller when we go for evening walks.

Pandora

(*following page*) Chosen for her striking calico fur pattern, this girl now belongs to a large, friendly family of artists and other rescue kitties. She is known as Panzy in her new home. When not busy serving as security guard and greeter in an art gallery, she spends her days chasing toy snakes and playing with the members of her adopted family.

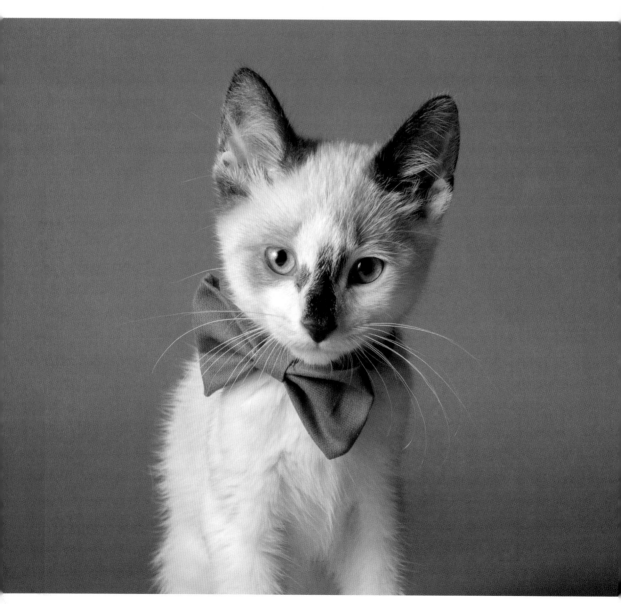

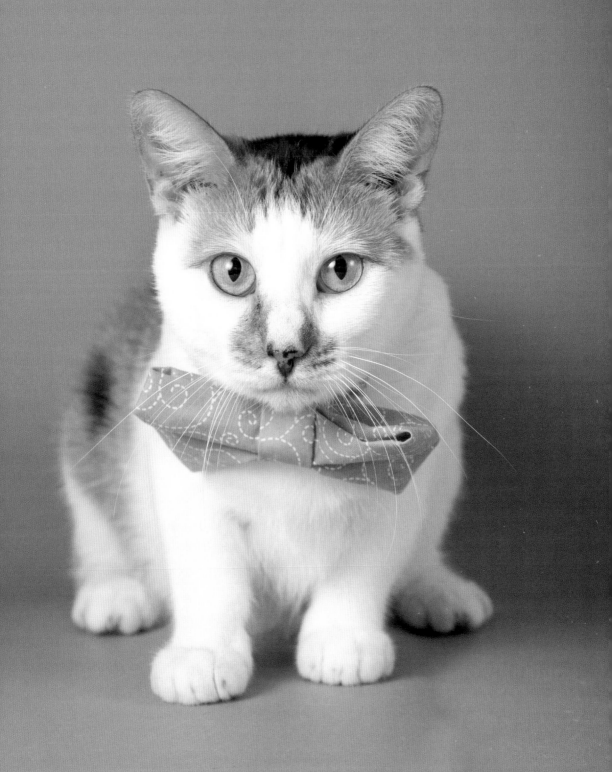

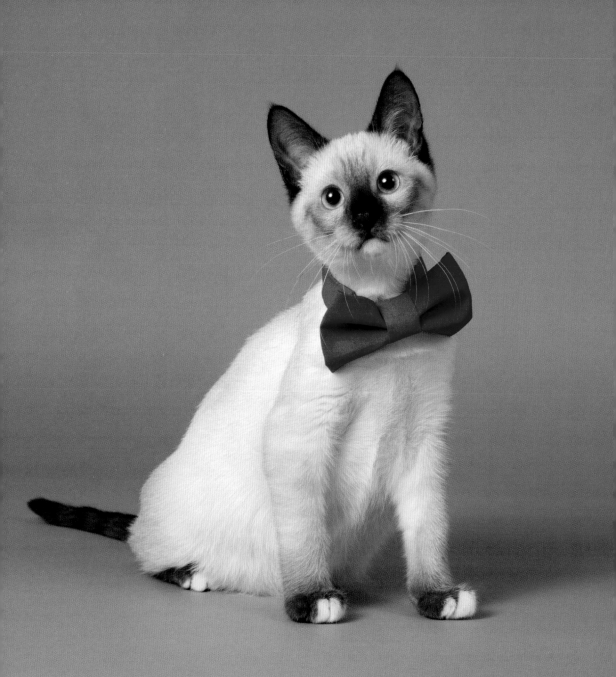

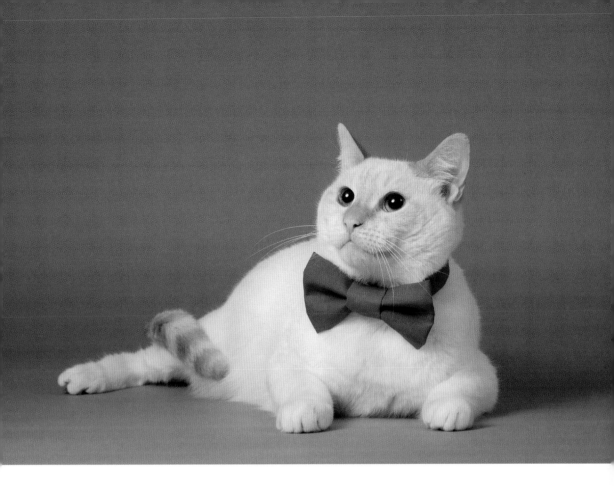

Silver

(previous page) Found hiding under a house along with his siblings, Silver was the runt of the litter. His adopter fell in love with his tiny size and adorable white toes.

Silver now accompanies his rescuer, the director of an assisted living home, to work. He oversees things in the office, keeps residents company, and sometimes even wears a bow tie to work. He loves going for car rides and being a faithful companion.

Silver grew into a massive cat, weighing in at over 20 pounds.

Harry

(above) Harry was brought to the clinic to be neutered after he wandered up to a woman's home from a local cemetery. Upon arrival, he tested positive for both feline leukemia and FIV. Due to Harry's apparent old age, medical needs, and wonderful laid-back personality, the staff at the clinic decided to take him in and allow him to make his home with them as the official clinic cat. He did not have contact with any of the feline patients. Harry was a very friendly and loving cat with a loud purr, and the ability to sleep anywhere. He passed away after only eight months with the staff, and he is missed by all who knew him.

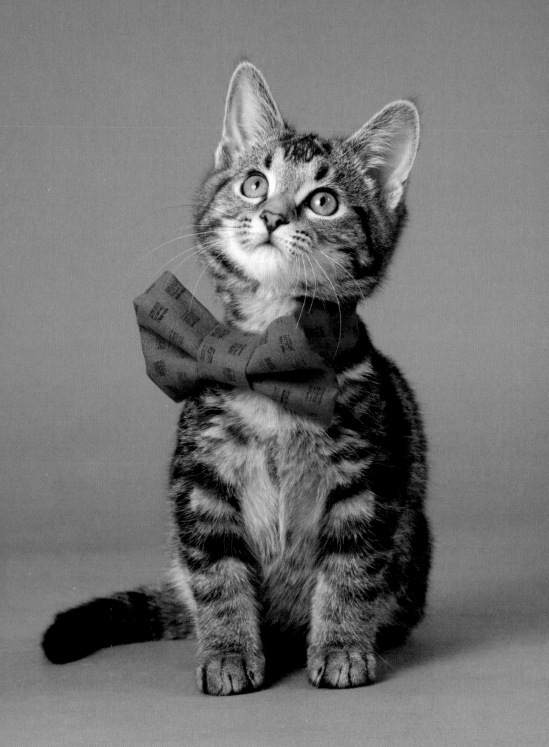

Sir Woody

(previous page) Perfectly gentle and good natured, this sweet kitten won the hearts of the Miss Kitty staff.

Sir Woody has grown into a large, handsome tabby and is now serving as a companion animal in an adult care home. He brings fun and smiles to the residents he visits, as well as friendship and comfort to the lonely.

Topaz

(below) Topaz was dropped off at the shelter when pregnant. Her kittens were born there and quickly found homes. After her long maternity stay, the staff had fallen in love with her charming personality. She is now the official clinic cat, welcoming patients and overseeing the staff as they file paperwork and make phone calls.

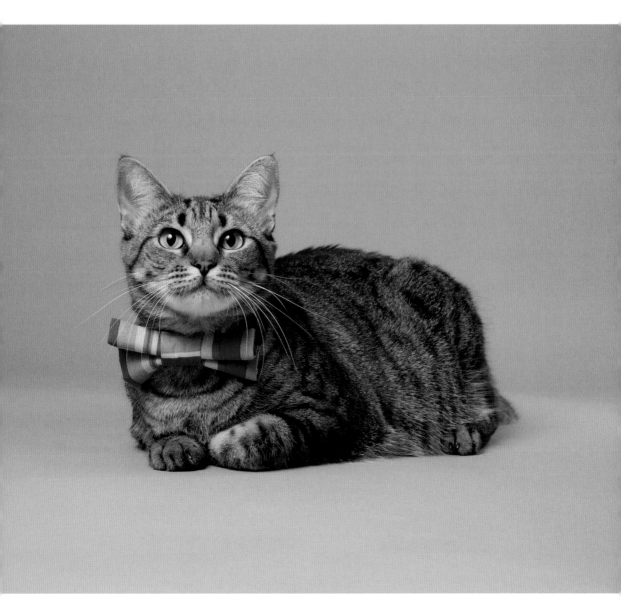

🐱 Cat Families

All Together Now

All from various rescue situations, the felines represented in this section now live together as roommates and are part of a feline family.

Sierra

Sierra *(below)*, Lady Gray *(page 100)*, Coal *(page 101)*, and Rafiki *(page 102)* love sleeping together each night in their own private cat room. All were rescued by Miss Kitty from various situations. Now, as a family, this wonderful group of kitties brings the love.

Sierra is a beautiful Siamese princess. Shy with strangers, she is very selective when it comes to determining who is allowed to pet her. Curiously, Sierra loves to snack on spiderwebs.

Sierra and her feline family were the inspiration for the volunteer work I contribute to the shelter.

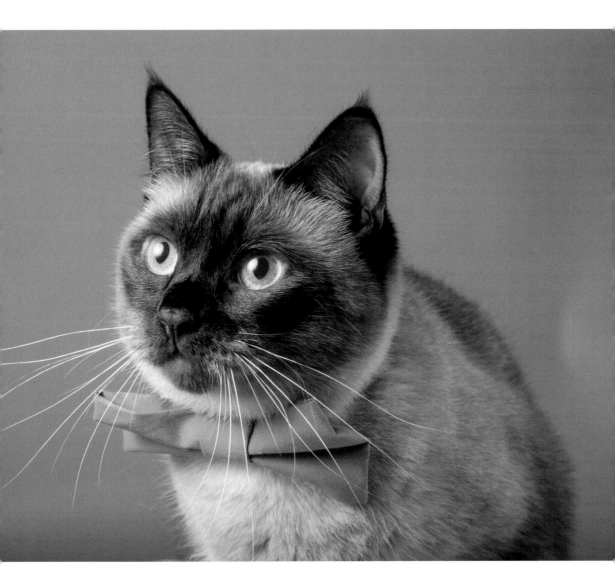

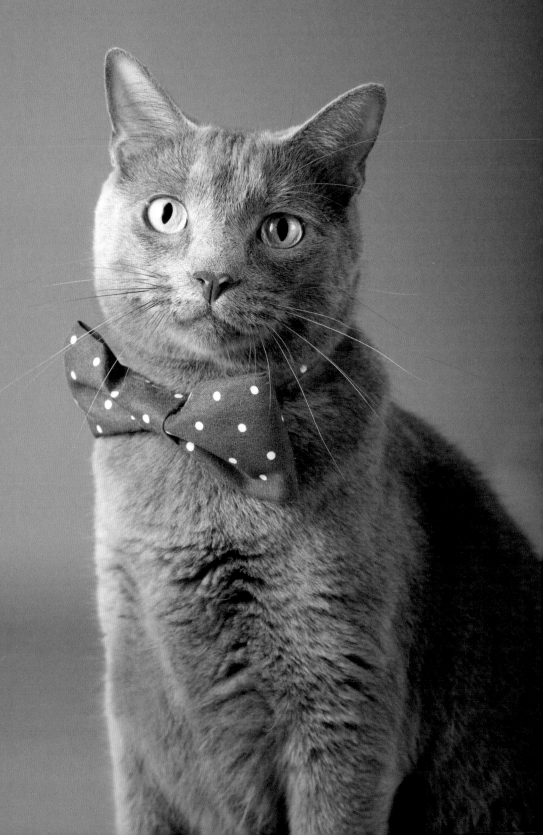

Lady Gray

(*previous page*) After hearing my dad's stories about his amazing experience adopting Sierra from Miss Kitty Feline Sanctuary, I had to see it for myself. I fell in love with the place, the staff, and all of the kitties on my first visit.

While there, we met Lady Gray. She had incredibly soft fur, a roaring purr, and was demanding of our attention. She formed an instant bond with my dad. One of the shelter staff informed us that if he wanted to adopt her, also, the fee would be waived. He immediately agreed to take her home.

Lady Gray is an incredibly affectionate member of the family. She loves everything and everyone and is curious about the world around her.

Coal

(*below*) Coal loves spending his days sniffing catnip and indulging in cat treats. His favorite game is hide and seek under any garment. He loves to dress up and is often spotted wearing a red bandanna.

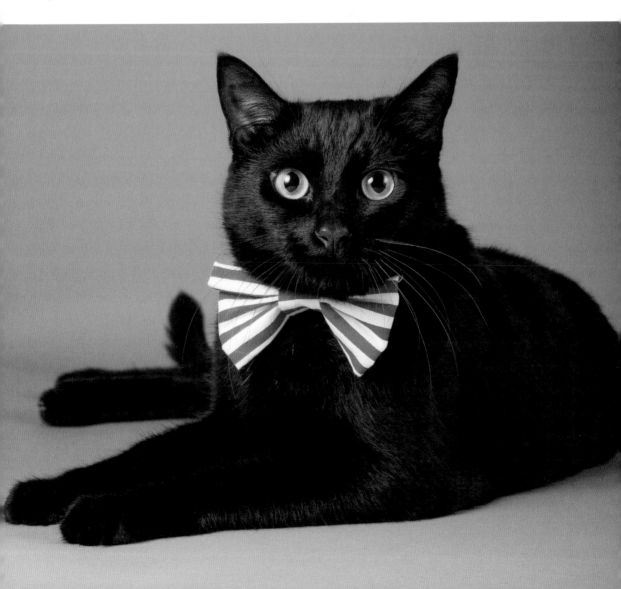

Rafiki

Rafiki belonged to a cat breeder but was unwanted because he was the runt of his litter. At the time of his adoption, he could fit in the palm of your hand. Sleeping was always his favorite pastime. This beautiful striped feline lived a long and happy 19-year life.

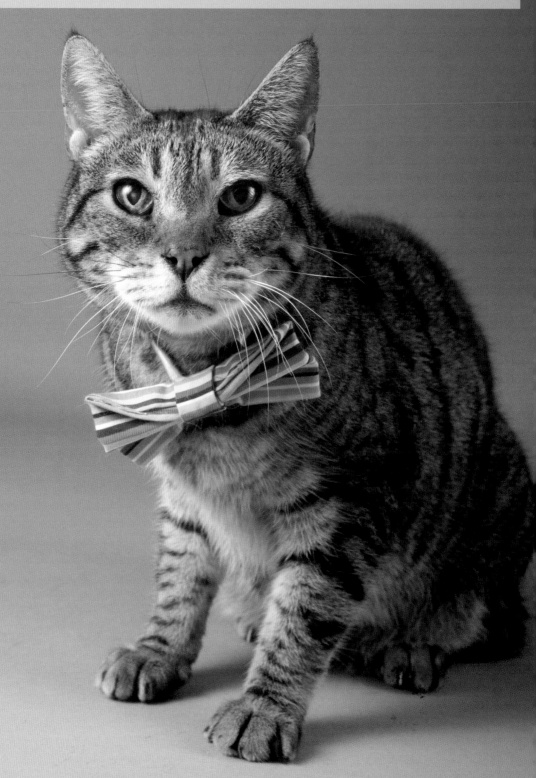

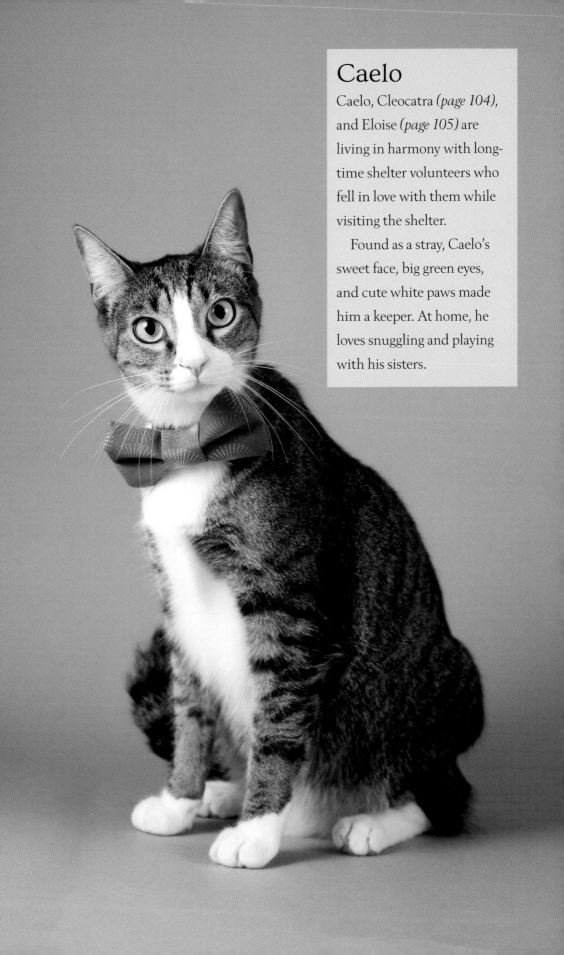

Caelo

Caelo, Cleocatra *(page 104)*, and Eloise *(page 105)* are living in harmony with long-time shelter volunteers who fell in love with them while visiting the shelter.

Found as a stray, Caelo's sweet face, big green eyes, and cute white paws made him a keeper. At home, he loves snuggling and playing with his sisters.

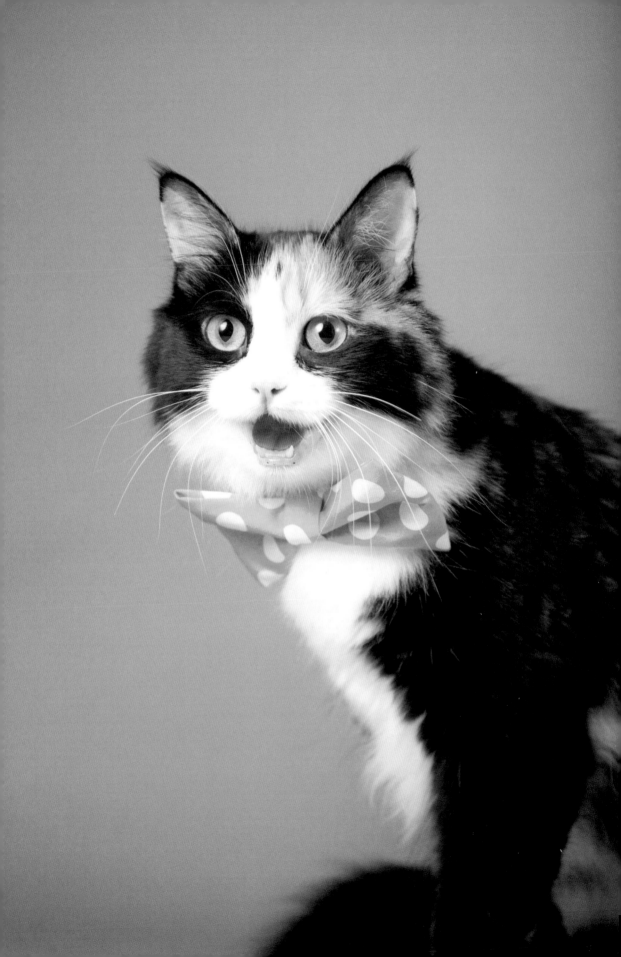

Cleocatra

(previous page) During my photo shoot with Cleocatra, she constantly talked to me, chirping and chattering all though the session. This long-haired beauty loves sniffing catnip and napping on a warm chest.

Eloise

(below) This Siamese lady loves dining on meals of tuna and chasing the laser pointer. Her nickname at home is Weezy.

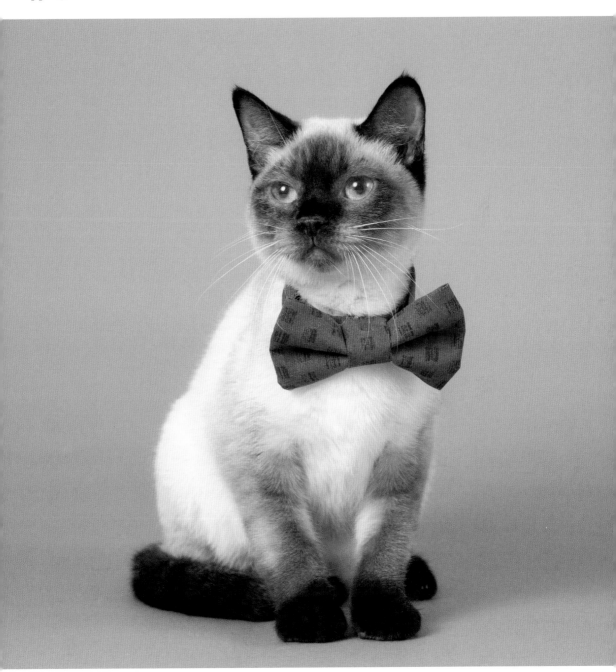

Piper

Piper, Pepper *(page 107),* and Poppy *(page 108)* are siblings from the same litter. They came into the shelter together as kittens and grew up together in foster care until they were old enough for shelter life. All three of these longhaired beauties found forever homes as soon as they were old enough to be adopted.

Piper's soft, gray fur, sheepish expression, big eyes, and paws are captivating.

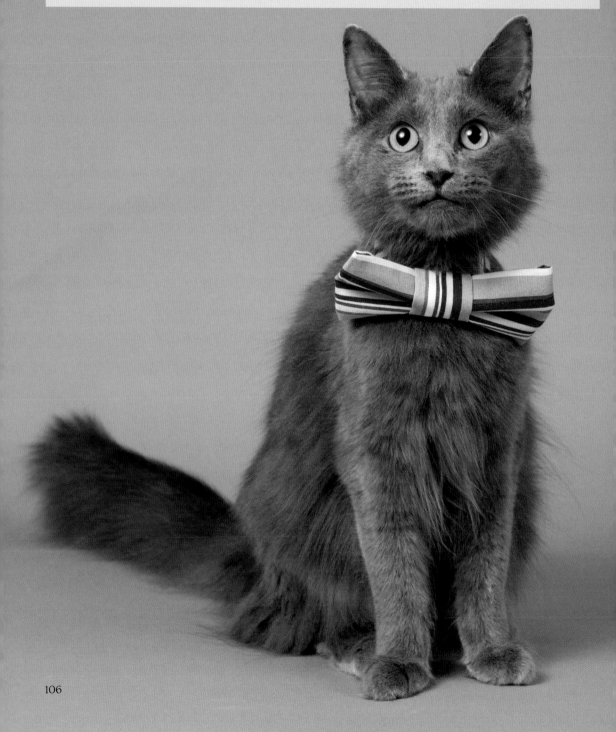

Pepper

Pepper's fluffy black fur and white whiskers give her such an elegant look. This kitty was wonderfully soft and sweet; photographing her was truly a pleasure.

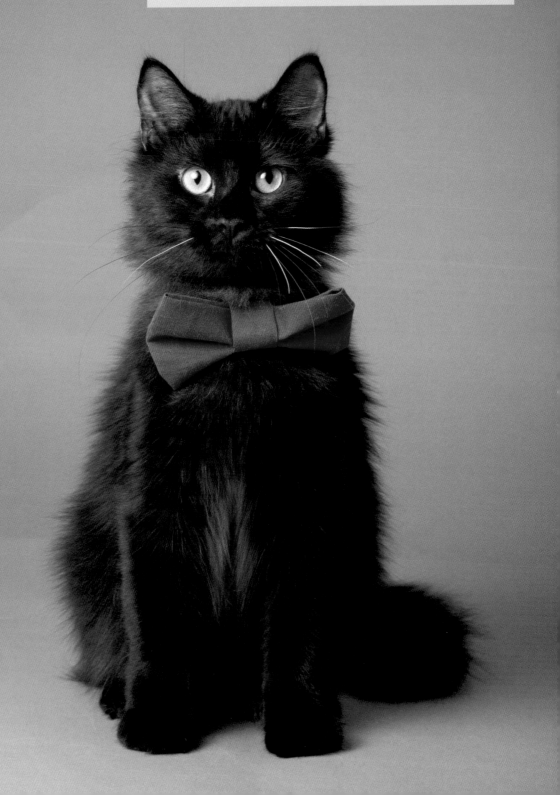

Poppy

No one is quite sure what happened to Poppy's tail, but its absence takes nothing away from his overall handsomeness.

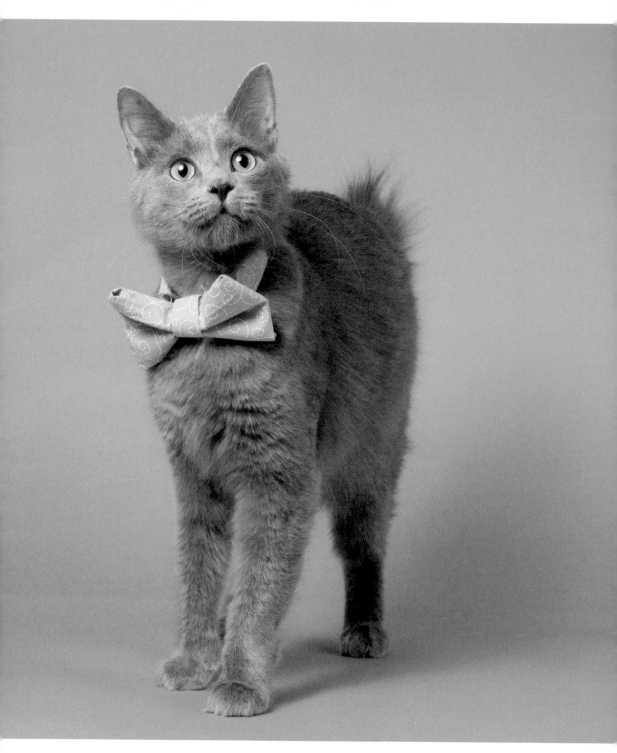

Captain

Captain (*this page*), Tigger (*page 110*), Scooter (*page 113*), and Princess Leah (*page 114*) live together in a big, happy household with caring humans who make time and space for kitties with special needs who need extra-special care.

Captain was found on the highway and taken to the shelter for rescue, but by the time he was saved, he had lost one eye. He is a frisky and playful hunter who loves to chase his housemates. He has mastered doing flips and somersaults and enjoys basking in the attention he receives for performing.

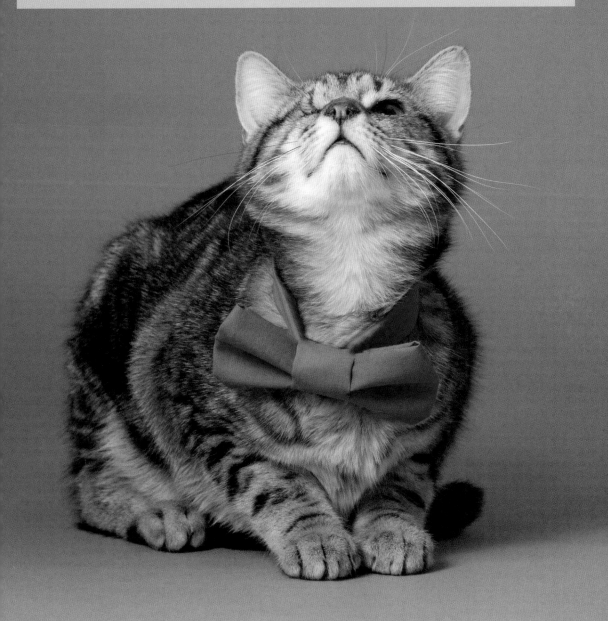

Tigger

Tigger and his littermates were all foster kittens from Miss Kitty. Unfortunately, all four kitties had feline leukemia and all but Tigger the Fighter passed away early on.

Tigger loved going for rides in his stroller and spending time on the screened-in porch, watching the birds and butterflies. He loved being held and spending time with his humans. Over time, the effects of the leukemia set in, and it was this handsome boy's time to cross the rainbow bridge.

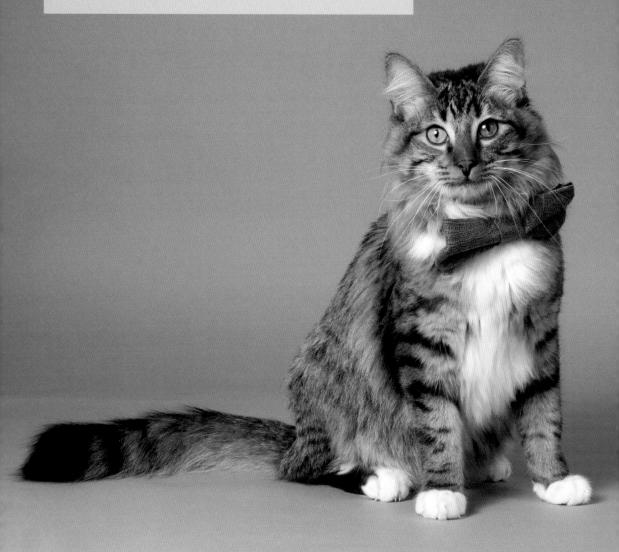

Scooter

This oversized gray fluff ball is the largest cat in the series, weighing in at 22 pounds. Scooter is a gentle, loving giant, and is incredibly vocal and affectionate. I loved snuggling with him during our photo shoot. At home, he is indulged with a special diet of venison to help support his health needs.

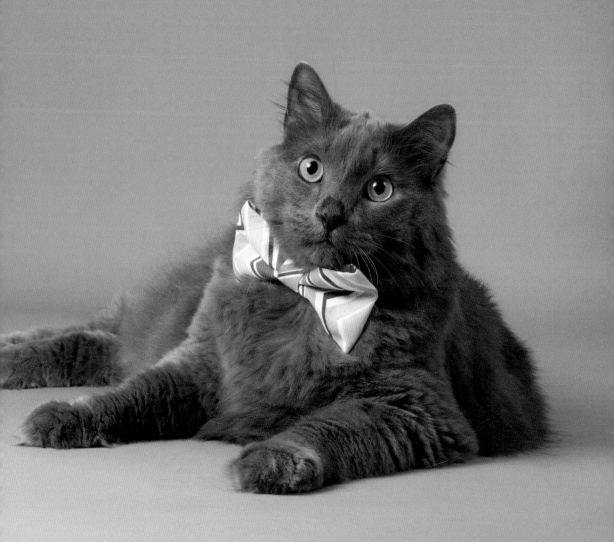

Princess Leah

Due to her rough start in life, Princess Leah has many physical impairments that require special care. She doesn't like being left alone and prefers to be near her family at all times.

Sharing her home with other kitties isn't easy, but Leah is definitely treated like the princess of the house, earning special meals like fresh chicken and shrimp.

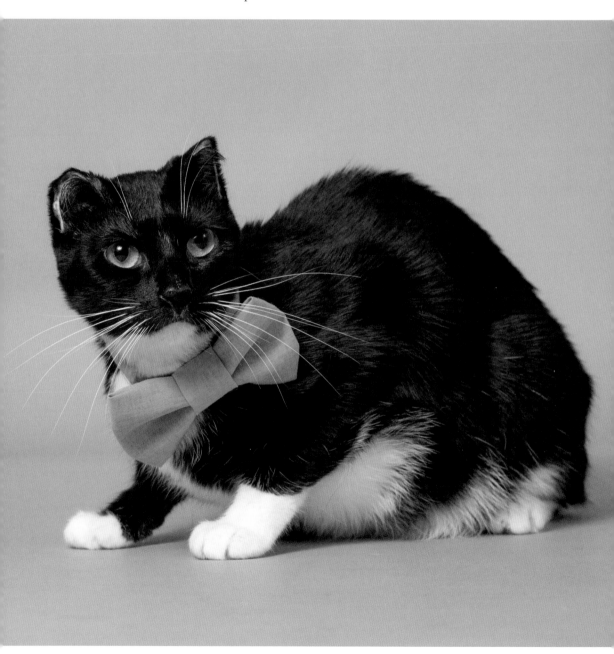

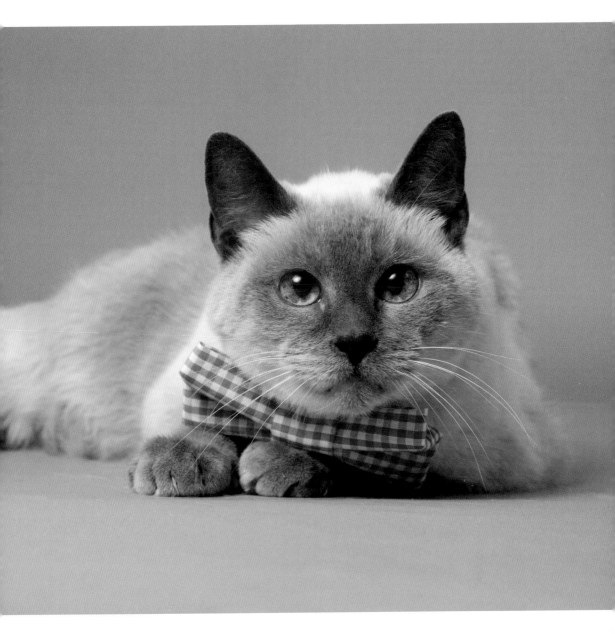

Jasmine

Jasmine *(above)*, Bat *(page 114)*, and Sir Ocelot *(page 115)* live together with a founding member of Miss Kitty. These adorable cats have formed their own feline family.

Jasmine was with a group of kittens scheduled to be put to sleep at a local county shelter. Now 16 years old, she has lived a long, happy life as a lap cat in her forever home.

Bat

(below) After Bat was left in the night drop-box of a local country shelter, his eye needed to be removed. Following his surgery, his funny face and teeth earned him the name of Bat.

Sir Ocelot

(following page) Sir Ocelot was found with a group of kittens wandering the grounds of a camp for children. He screamed loudly when left alone and needed extra attention and care, so he came to live in a loving home with an experienced rescuer who could attend to his every need.

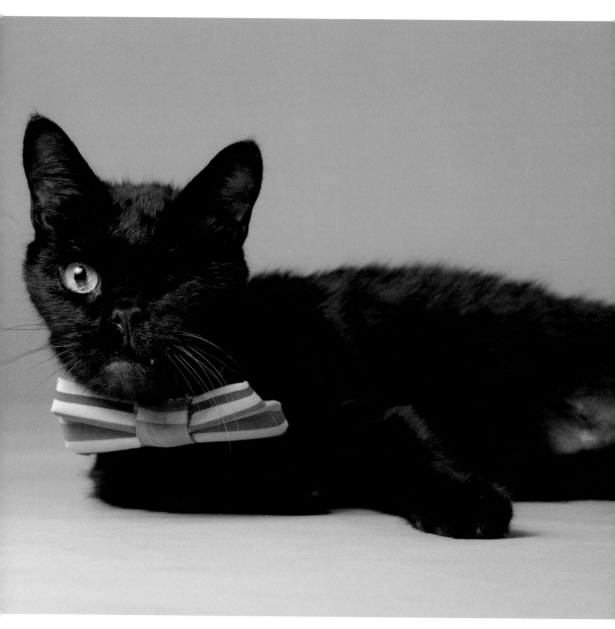

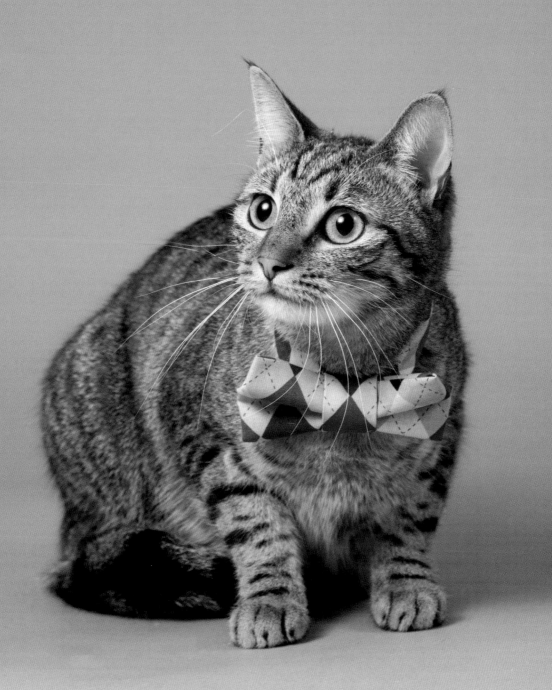

Café Cats

Sophisticated Felines

Animal shelters require many partners to aide in adoption and help cats and cat lovers connect. Cat cafés are a wonderful partner in this endeavor. These establishments are coffee shops with cats housed on the premises. The cats are usually kept in a special room outfitted with toys, cat trees, large windows, and comfy places for cats and humans to lounge and play. People pay to interact with these cats.

"Many cat cafés partner with local animal shelters and serve as adoption agencies for the kitties in their care."

Coffee and treats with a feline theme are often served to patrons of these cafés. They are a wonderful place for cat lovers to relax and socialize. Many cat cafés partner with local animal shelters and serve as adoption agencies for the kitties in their care. Potential adopters meet and get to know the kitties before considering adoption. These cafés reach out to crowded shelters when they need new feline residents.

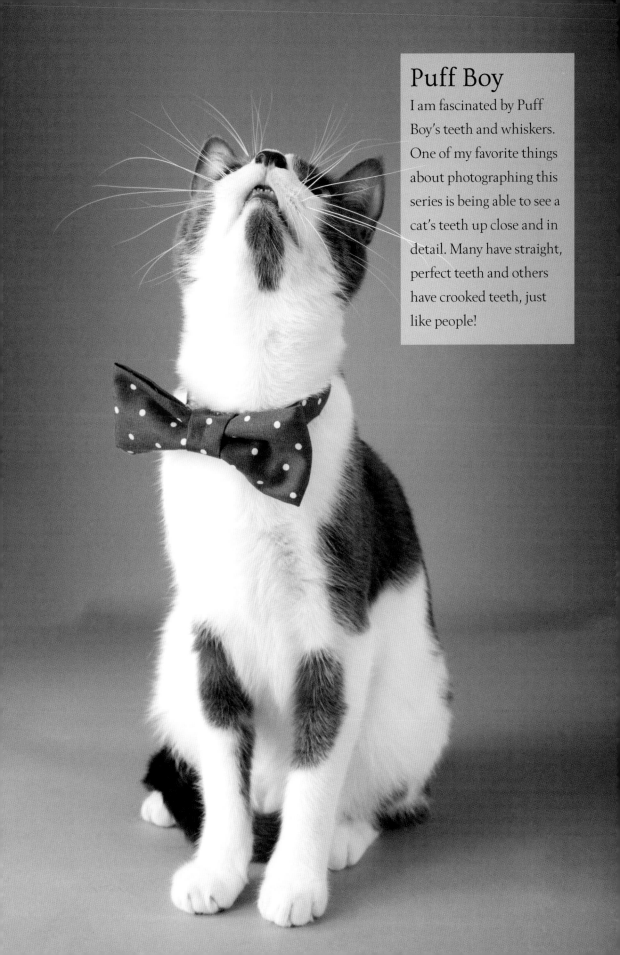

Puff Boy

I am fascinated by Puff Boy's teeth and whiskers. One of my favorite things about photographing this series is being able to see a cat's teeth up close and in detail. Many have straight, perfect teeth and others have crooked teeth, just like people!

Grey Stroke

Grey Stroke has the most mischievous expressions and attitude. I loved photographing this magnificent green-eyed gentleman. Grey Stroke eventually made his way to the Orlando Cat Café in Clermont, Florida, where he met his adopter and found his forever home.

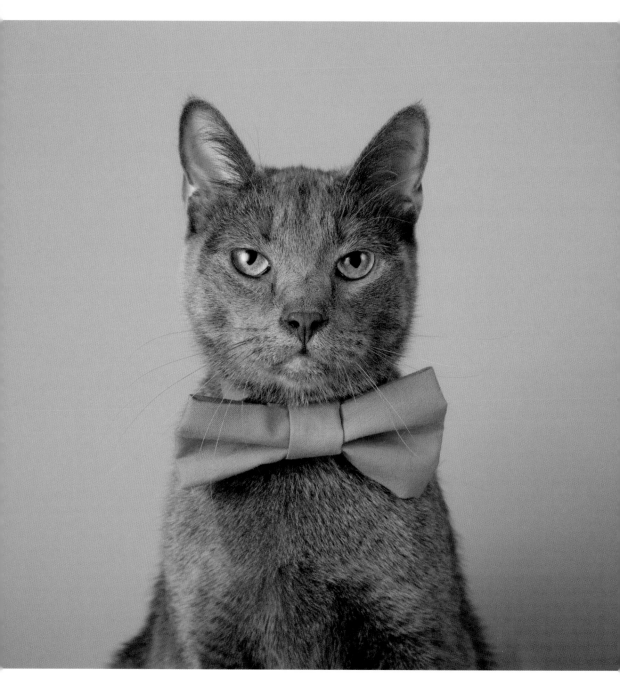

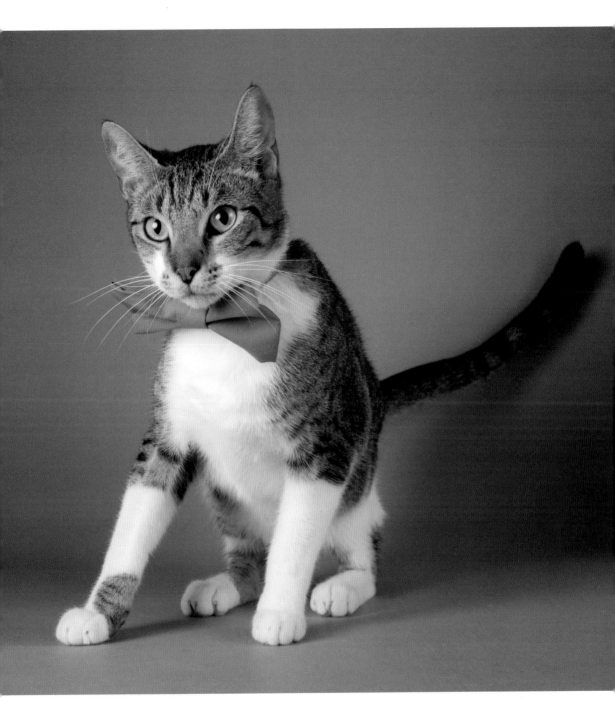

Jefferson

Jefferson's mother was found trapped in the engine of a car by the Miss Kitty crew. She was taken into the shelter and gave birth to Jefferson on the 4th of July. Jefferson was taken to the Orlando Cat Café, where he found his forever family.

Pretty Girl

Pretty girl was extremely shy. She allowed me to dress her in a bow tie and brush her fur for the photo, but as soon as I lifted the camera and took one shot, she ran and hid. Though she was camera shy, I was able to capture a beautiful shot.

Pretty Girl eventually warmed up to people and moved into a cat café, where she found her forever home.

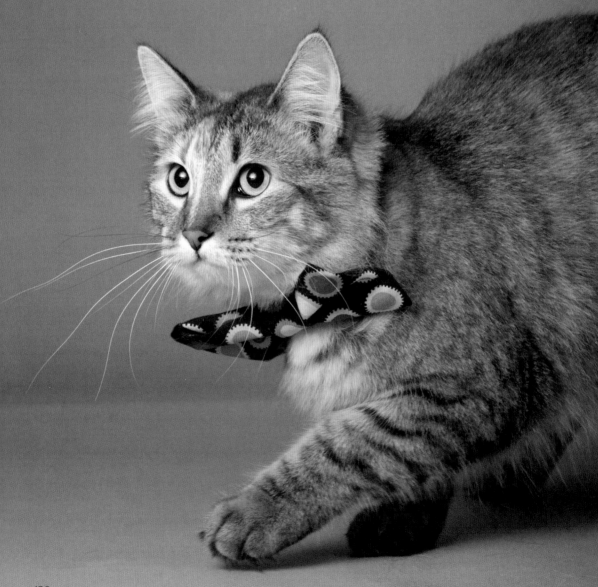

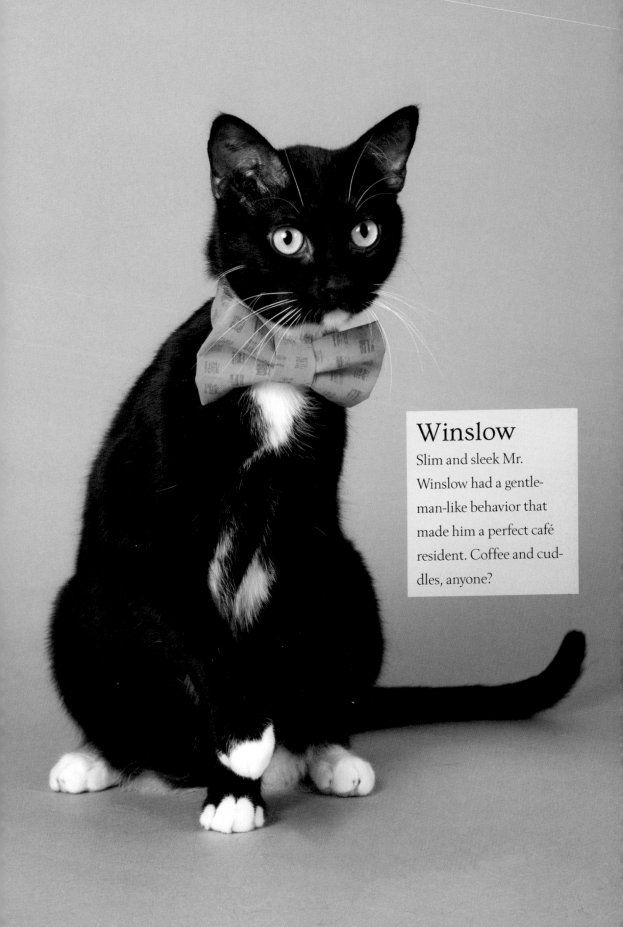

Winslow

Slim and sleek Mr. Winslow had a gentle-man-like behavior that made him a perfect café resident. Coffee and cud-dles, anyone?

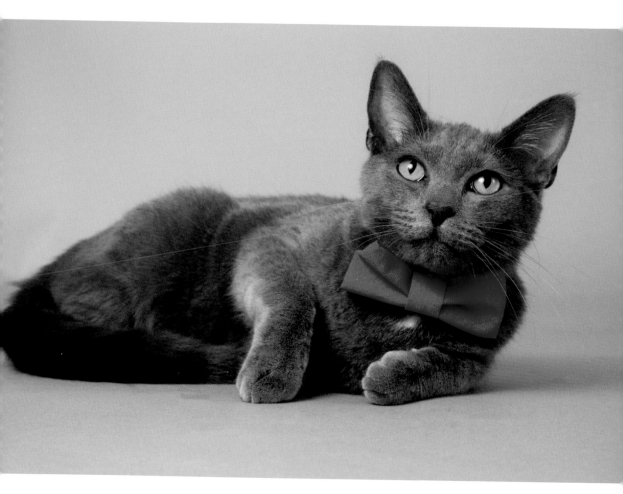

Jimbo

This laid-back hunk was once lost, and was found wandering the streets. He was eventually taken to Miss Kitty, where he lived for about a year and then eventually moved on to become a café cat. After several months of café life, Jimbo met a loving family and moved in with them.

"After several months of café life, Jimbo met a loving family and moved in with them."

⚈ Craft a Bow Tie

A Simple Guide

With just a bit of patience and craftiness, you can make a bow tie for your cats to proudly wear. In just a few minutes, using supplies you may have around your home, your kitties can be on their way to a stylish new wardrobe—no sewing required! This basic guide shows you how to fold and glue small scraps of fabric into a basic bow tie shape that will fit on your cat's collar.

Supplies needed:

- scrap fabric
- hot glue gun
- glue sticks
- scissors

Start your project with two rectangular pieces of fabric. One should be approximately 5x6 inches; the other should measure roughly 3x2 inches.

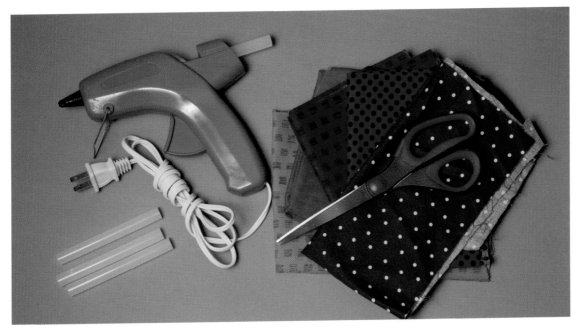

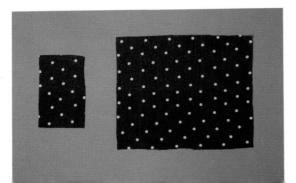

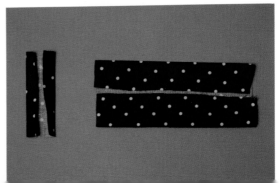

▼ Take the larger piece of fabric and fold the ends toward the center.

▼ Pinch the large folded piece of fabric in at the center to create a bow-tie shape. Drop a dab of hot glue onto both sides to keep the fabric in place. Be careful not to burn your paws!

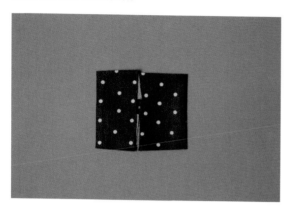

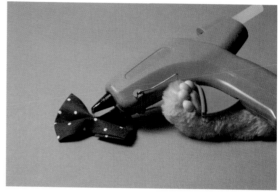

▼ Next, fold the ends of the smaller fabric piece toward the center. Wrap it around the center of the bow tie, drop a dab of glue on the back side, and press it together.

▼ Once the glue has cooled, the bow tie is complete. You can run your cat's collar through the loop created at the center of the bow tie. Find your cat and take some pictures!

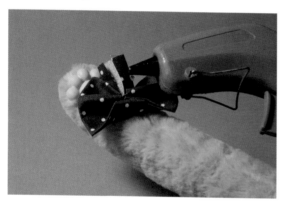

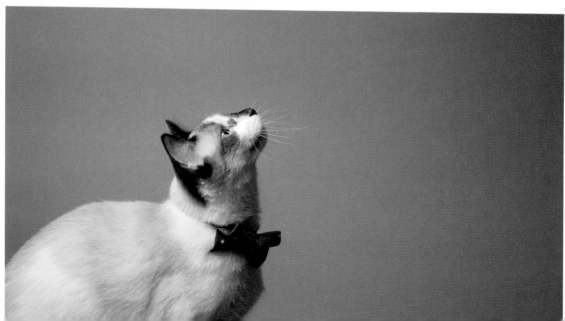

Acknowledgments

So many people contributed to the creation of the Cats in Bow Ties series. Creating this series has certainly been the highlight of my career as a photographer. Any true cat person can tell you that one of our favorite things to do is talk about our cats, tell people how they are, and show off photos of them. Don't believe me? Start a conversation about cats with a known cat lover and see how long it takes for them to start showing you photos.

Writing and putting this book together and sharing the photographs and stories of these beautiful felines has been an incredible labor of love, and I am grateful for the privilege to do so. I thank Amherst Media for giving me the opportunity to create this book and share this project with cat lovers across the globe. Thank you to my loving husband, Ron, for allowing our home to be transformed into Cats in Bow Ties headquarters. Over the years it has taken for me to create this series, our living room has been in a constant state of transformation from photography studio to video set, to bow tie factory, to storage space for all the necessary equipment. You have been there throughout my life as a photographer, and I am eternally grateful for your love and support throughout all of my artistic endeavors. Mom, thank you for always allowing me to own cats and take in kittens as a kid. Cats have always been the highlight of my life, and I am grateful that you were always willing to make space in our home for one more cat. Thanks, too, for sitting with me for hours, helping me craft bow ties for this series. Dad, thank you for teaching me to love Siamese cats and for being my number one fan and supporting any crazy idea I have ever had throughout my life. You introduced me to Miss Kitty Feline Sanctuary and changed my life on that adventure. Thank you for being a cat wrangler and tagging along with me on my many trips to the shelter for photo shoots to create this series. Thank you to my sister-in-law, Gloria, for her help in dressing, posing, and entertaining kitties at the shelter during many photo shoots—and for opening your heart and home and taking in that cats we fell in love with during these sessions. Your patience, kindness, and love for cats is a virtue. Thank you to my photography assistant and best friend, Lauren. From weddings to cats, you are my right hand. On long days and late nights, you are always willing to tag along and keep me laughing, no matter how dire our situations may be. Thank you for burning your fingers making bow ties and allowing dozens of cats to sink their claws into your shoulders and cover your clothing in fur while we worked at the shelter. Thank you to Dana for being a lifelong influence, trusted advisor, friend, and favorite teacher. Thank you to the founders and volunteers of Miss Kitty Feline Sanctuary and South Georgia Low-Cost Spay and Neuter Clinic in Thomasville, Georgia. Your work has changed the world. The lives of 1000s of animals and humans have been impacted by the charity, service, and compassion you provide to your community. Regina, without you, most of the cats in this book would not be alive. You have rescued, nursed, and loved more cats than anyone can count. You're a hero to cats and an inspiration to anyone in the rescue. Thank you, Natalie, for helping organize and execute multiple Cats in Bow Ties events and photo shoots. Carol, my friend at first sight: thank you for living a life of inspiration, being a best friend to animals, and for being an incredible role model. Without your support and encouragement, the Cats in Bow Ties series would not be. Finally, a big thank you to all of the cats that allowed me to

photograph them and the wonderful people who have opened their homes to rescue these amazing felines.

To keep up with and learn more about the Cats in Bow Ties project, please visit:

- www.catsinbowties.com
- www.instagram.com/101catsinbowties
- www.facebook.com/catsinbowties

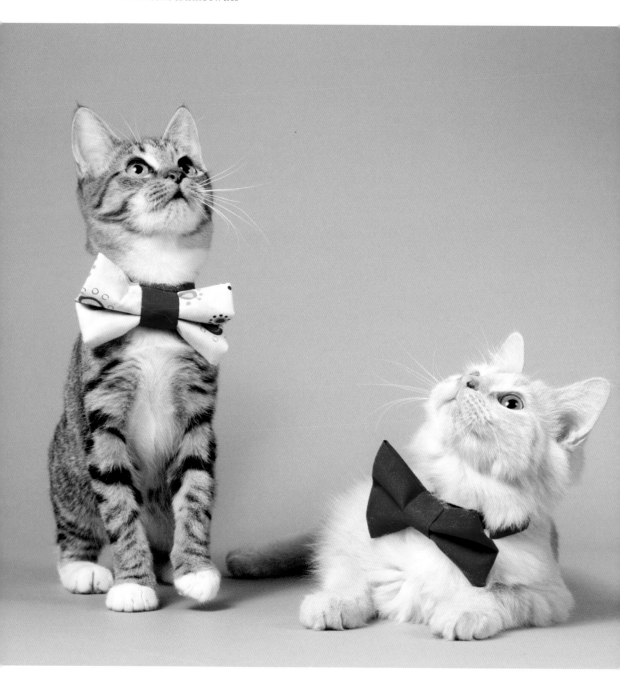

Index

AmherstMedia.com

- *New books every month*
- *Books on all photography subjects and specialties*
- *Learn from leading experts in every field*
- *Buy with Amazon (amazon.com), Barnes & Noble (barnesandnoble.com), and Indiebound (indiebound.com)*
- *Follow us on social media at: facebook.com/AmherstMediaInc, twitter.com/AmherstMedia, or www.instagram.com/amherstmediaphotobooks*

Who Rescued Whom?
PORTRAITS & RESCUE STORIES

Photographer Margaret Bryant shares unforgettable images and stories that celebrate the unbreakable human-canine bond. *$24.95 list, 7x10, 128p, 200 images, index, order no. 2209.*

Rescue Rabbits PORTRAITS & STORIES OF BUNNIES FINDING HAPPY HOMES

Susan Maynard shares adorable images and heartwarming stories of sweet bunnies finding their forever homes. *$21.95 list, 7x10, 128p, 200 color images, index, order no. 2196.*

The Frog Whisperer
PORTRAITS AND STORIES

Tom and Lisa Cuchara's book features fun and captivating frog portraits that will delight amphibian lovers. *$24.95 list, 7x10, 128p, 350 color images, index, order no. 2185.*

Cats 500 PURR-FECT PORTRAITS TO BRIGHTEN YOUR DAY

Lighten your mood and boost your optimism with these sweet and fiesty images of beautiful cats and adorable kittens. *$24.95 list, 7x10, 128p, 200 color images, index, order no. 2197.*

Fancy Rats
PORTRAITS & STORIES

Diane Özdamar shows you the sweet and snuggly side of rats—and stories that reveal their funny personalities. *$24.95 list, 7x10, 128p, 200 color images, index, order no. 2186.*

Horses
PORTRAITS & STORIES

Shelley S. Paulson shares her love and knowledge of horses in this beautifully illustrated book. *$24.95 list, 7x10, 128p, 220 color images, index, order no. 2176.*

Wild Animal Portraits

Acclaimed wildlife photographer Thorsten Milse takes you on a world tour, sharing his favorite shots and the stories behind them. *$24.95 list, 7x10, 128p, 200 color images, index, order no. 2190.*

Dogs 500 POOCH PORTRAITS TO BRIGHTEN YOUR DAY

Lighten your mood and boost your optimism with these sweet and silly images of beautiful dogs and adorable puppies. *$19.95 list, 7x10, 128p, 500 color images, index, order no. 2177.*

Penguins in the Wild
A VISUAL ESSAY

Joe McDonald's incredible images and stories take you inside the lives of these beloved animals. *$24.95 list, 7x10, 128p, 200 color images, order no. 2195.*

Show Cats
PORTRAITS OF FINE FELINES

Larry Johnson shares photos and stories of incredible cats and how he coaxes them into amazing images. *$19.95 list, 7x10, 128p, 180 color images, index, order no. 2166.*